General Editor
David Piper

# Toulouse-Lautrec

## Every Painting    II

M. G. Dortu and J. A. Méric

translated by Catherine Atthill

D1334162

# *Foreword by the General Editor*

Several factors have made possible the phenomenal surge of interest in art in the twentieth century: notably the growth of museums, the increase of leisure, the speed and relative ease of modern travel, and not least the extraordinary expansion and refinement of techniques of reproduction of works of art, from the ubiquitous colour postcards, cheap popular books of colour plates, to film and television. A basic need – for the general art public, as for specialized students, academic libraries, the art trade – is for accessible, reliable, comprehensive accounts of the works of the individual great masters of painting; this has not been met since the demise before 1939 of the famous German series, *Klassiker der Kunst*; when such accounts do appear, in the shape of full *catalogues raisonnés*, they are vast in price as in size, and beyond the reach of most individual pockets and the capacity of most private bookshelves.

The aim of the present series is to provide an up-to-date equivalent of the *Klassiker* for the now enormously enlarged public interested in art. Each volume (or volumes, where the quantity of work to be reproduced cannot be contained in a single one) catalogues and illustrates chronologically the complete paintings of the artist concerned. The catalogues reflect as far as possible a consensus of current expert opinion about the status of each picture; in the nature of things, consensus has yet to be reached on many points, and no one professionally involved in the study of art-history would ever be so rash as to claim definitiveness. Within the bounds of human fallibility, however, every effort has been made to achieve both comprehensiveness and factual accuracy, while the quality of reproduction aimed at is the highest possible in this price range, and includes, of course, colour. Every effort has also been made to hold the price down to the lowest possible level, so that these volumes may stay within the reach not only of libraries, but of the individual student and lover of great painting, so that they may gradually accumulate their own 'Museum without Walls'. The introductions, written by acknowledged authorities, summarize the life and works of the artists, while the illustrations place in perspective the complete story of the development of each painter's genius through his career.

*David Piper*

# Introduction

The year 1891 brought several events which were to alter the course of Toulouse-Lautrec's private life, give his art a new and freer direction and attract the attention – usually hostile, occasionally appreciative – of his contemporaries and critics.

First, Gabriel Tapié de Céleyran came to Paris to study medicine. Gabriel, five years Lautrec's junior, was his first cousin twice over (his father was a brother of Lautrec's mother and his mother a sister of Lautrec's father). They became close friends and the ill-matched pair – one tall and gawky, the other grotesquely stunted – often appear in Lautrec's pictures. Gabriel willingly accepted his role as butt of his cousin's high spirits and later helped Maurice Joyant set up the museum at Albi.

Lautrec often visited the hospital with Gabriel, and the operating theatres where he watched Péan, the surgeon, and his team at work were the setting for a new experience which fired his natural curiosity. 'If I weren't a painter I'd like to be a surgeon,' he declared with customary enthusiasm, spellbound by the drama of the surgeon's efforts to save life. This new facet of experience found expression in a large number of drawings. Here the simplicity of line, reduced to essentials, and his restrained handling of the subject matter reflect Lautrec's admiration for Japanese art and its influence on his work. One picture, *Doctor Péan performing a Tracheotomy* (No. 328), shows how far Lautrec's art had progressed: he conveys the drama of the scene by his use of flat, sober colour, and communicates the intensity of the moment without trivial or distracting detail.

The second important event in Toulouse-Lautrec's development as a painter in 1891 was of a rather different kind. Two years before, a huge, brand-new dance hall, the Moulin Rouge, had opened near the Moulin de la Galette, whose decline it was to mark. A striking poster by Jules Chéret advertised the opening and it was an immediate success.

Chéret had learned poster art in England where the use of lithographic processes had encouraged this form of advertising, as yet virtually unknown in France. On his return to that country he turned his attention to the walls of Paris, plastering them with the frivolous, gaily-coloured antics of ladies who extolled the virtues of anything from oil lamps to bicycles, aperitifs, and *cafés-concerts*. His Moulin Rouge poster was his masterpiece, to the delight of Zidler the proprietor.

Lautrec immediately began to frequent the dance hall and its extravagant entertainments. He sketched La Goulue and Valentin-le-Désossé and produced large paintings for Zidler to hang in the entrance. But fashions change and the opening of the Casino de Paris marked the birth of a rival which soon outstripped the Moulin Rouge. (Today only these two survive, all the others having vanished long ago.) Zidler and his partner Oller decided to add a host of extravagant new stars to their show. With Lautrec's works already hanging on their walls they asked him to produce a poster to advertise the revival.

Lautrec knew Chéret and admired his technique. His eye-catching posters were meant to be seen from a distance and so were relatively restrained and similar in technique to that of the Japanese artists Lautrec so admired. Lautrec himself knew nothing about lithography and had no model to imitate. But he transformed the styles of those he regarded as his masters – Degas, the Impressionists and the Japanese – and created a completely original poster, quite unlike anything that had gone before with its bold simple colours, economy of line and above all its irresistible sense of movement and excitement. It was a triumph. 'Today my poster is all over the walls of Paris,' he wrote to his mother in December 1891. A contemporary critic reviewed it thus: 'Lautrec really is a cheeky devil. There's no fuss about his drawing or colour. Great slabs of white, black and red, simple shapes, that's all there is to it. What a nerve! What an insult! It's a real slap in the face for people who really only like pap.'

At this time Lautrec, who visited brothels regularly, began to live in them for longer periods. He was fascinated by the life-style he found there, especially by the private lives of

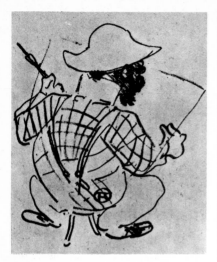

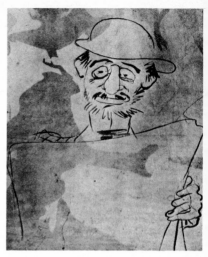

*Although Lautrec did not like self-portraits, he did enjoy capturing his own features in unflattering, caricatured sketches.*
(Above left) *A drawing of 1896, dedicated* A Pellet,

*l'intrépide éditeur (Albi, Musée Toulouse-Lautrec); (above right) a pen-and-ink sketch, drawn on the back of a copy of the* Divan Japonais *poster in 1898 (Mme Dortu collection).*

the women with whom he was soon on familiar terms. His kindness and good humour, caustic wit and charm won them over, and they were even more impressed by his virility. Usually he went with a friend, often Maurice Guibert. He was always extremely matter-of-fact about his visits, letting his friends know his temporary address and inviting them to come and see him.

He enjoyed telling people who seemed shocked by his way of life how on one occasion at three in the morning he had sent home a journalist with a social conscience and one of the official censors, both much the worse for drink, whereas he, for once, had been a model of sobriety. '*Ah! la Vie, la Vie!*' he would exclaim.

Obviously Lautrec's relationships with women were hampered by his physical deformity, but he adored women in general and had a number of mistresses from the world he frequented, notably Suzanne Valadon and Jane Avril of whom he remained fond.

He worked furiously and at intervals returned to his studio to paint picture after picture from the endless drawings he made. Often he took one of the prostitutes home with him as a model. He never exhibited these

intimate works: he might show them to friends, but took care never to shock people deliberately. Beneath a brazen exterior he concealed great moral delicacy. Once a man, out with his mistress, and whose wife was also notoriously easy-going, asked Lautrec in Maurice Joyant's hearing how he could bear to live in such places. Lautrec's sharp rejoinder was that it was better than making a cesspit of one's own house.

For two years Lautrec continued this hectic round of work, night-clubs and drinking. It was beginning to ruin his health but he seemed irresistibly drawn to this way of life. He was earning nothing and spending recklessly and, brought up as he had been to take money for granted, he began to be beset by financial worries. From now on he was always in debt and most of his letters to his mother mention the fact.

June 1891: 'Could you be kind enough to send me a few sesterces on about the glorious 14th July to pay off various tradesmen. I should be very grateful if you could.'
July 1891: 'Thank you in advance for sending 500 francs for my suppliers.'
July 1891: 'Ma Chère Maman,

You must have received your long-eared daughter. I had to pay carriage so you owe me 34f50 . . .

PS I shall probably need a large sum to settle some bills. We can discuss this later.'

Far from being the rich dilettante many of his contemporaries imagined, Lautrec lived in a state of constant anxiety about creditors. His output of work was remarkable, but this did not interfere with his outings to the theatre and opera, to cabarets, dance halls and *cafés-concerts*, his drinking bouts and friendships with prostitutes, his trip to London to see the National Gallery or his visits to exhibitions. But gradually he was burning himself out.

The success of his Moulin Rouge poster brought requests for many more: one for the newspaper *La Dépêche de Toulouse*, one for his mistress Jane Avril, two for Aristide Bruant, one for Victor Joze, the writer, to advertise his novel *Reine de Joie* ('Queen of Pleasure'), then another for Jane Avril, a third for Bruant and one for Caudieux the comedian. *Le Matin* ordered one to advertise *Au pied de l'échafaud* ('At the Foot of the Scaffold'), the memoirs of a prison chaplain.

Lautrec was delighted with his discovery of lithography. Immediately after the Moulin Rouge poster he produced his first two coloured lithographs, *At the Moulin Rouge: La Goulue and La Môme Fromage* and *The Englishman at the Moulin Rouge*. He put an enormous amount of work into these. Besides repeated sketches, he did a painting for the first (No. 362) and for the second two studies, one of Mr Warrener's head, now in the museum at Albi, and the other a fine painting (No. 364). These lithographs are among Lautrec's finest. They are examples of that blend of genius and hard work which allowed him to produce some of his most outstanding works and his first and finest poster (perhaps the finest poster ever) for the Moulin Rouge all at the same period.

And so it was a night-club proprietor who helped Lautrec discover lithography. The technique enthralled him and had a profound influence on his painting. The years 1891–2 saw a significant advance in his artistic development, as he progressed beyond the influence of Degas and the Impressionists to his own original style, with its economy of line and use of flat tints to capture what were always for him the essentials – life and movement.

Most of the paintings from this period are portraits of his friends and models, usually done in his studio, sometimes in Forest's garden. His friend Dr Henri Bourges (No. 320), who lived with him at Rue Fontaine is shown pulling on his gloves as he leaves Lautrec's studio, a pile of canvases stacked against the wall by his feet. M. Manuel leans on his umbrella (No. 321) or sits in Lautrec's wicker chair (No. 322). Other subjects include the photographer Paul Sescau (No. 327), a girl with a fur (No. 331) and models combing their hair among the rumpled bedclothes (Nos 333–5). The Dihau family pose in M. Forest's garden (Nos 323–5), and Justine Dieuhl (No. 338) sits quietly, hands folded in her lap, an enigmatic smile on her lips. The smartly dressed figure of Honorine Platzer appears twice in the same costume (Nos 340 and 341), seated in profile and standing full face.

Lautrec also painted scenes of Paris nightlife and pictures of the Jane Avril he loved – entering or leaving the Moulin Rouge, lost in thought (Nos 356 and 358), and dancing with the light step which earned her the nickname 'La Mélinite' after the explosive (No. 357).

In the enclosed world of the brothels

*Lautrec in a rather touching portrait by Vuillard, painted at the house of their mutual friends, the Natansons, at Villeneuve sur Yonne (Albi, Musée Toulouse-Lautrec).*

Lautrec, 'their' painter, was a popular figure. It was amusing for him to decorate the salon of the *maison* in Rue d'Amboise with a series of portraits of the women, set in medallions on panels (Nos 377–8). He captured disconcertingly intimate moments between these women, able to find affection only in each other, private pictures which Lautrec gave his friends but refused to exhibit or sell (Nos 373–6).

Lautrec's work was not confined to paintings, posters and lithographs. He also liked doing illustrations for newspapers and magazines; he wanted his work to be more widely known. He often said that paintings were done for the pleasure of a few, but that art should be widely available for all. He was eager to have his work published in *L'Art français, Le Courrier français, L'Escarmouche* and many others, particularly the little magazine *Le Mirliton*, belonging to his friend Aristide Bruant, in which Bruant used to print the words of his songs with illustrations by Lautrec. This opened up a new area of work for Lautrec and he began to do illustrations for new songs to be sold as sheet music by the hundreds of street singers of Paris. He also began illustrating theatre programmes and book jackets, and eventually moved on to book illustration.

When Yvette Guilbert made her stage début at the Divan Japonais she also made an unsuspecting conquest of Lautrec. Joyant described her: 'A thin figure in a sheath of green silk, arms encased in black, red-haired and pale, with a snub nose, a sad clown's mask, a drawling voice lingering over her words – an unrivalled *diseuse*'. Lautrec followed her wherever she went. He made endless sketches, fascinated by the gestures and skill as a performer of this woman who soon became the darling of Paris and later took America by storm. So great was her effect on him that he had not the courage to speak to her until a mutual friend introduced them four years later. Lautrec then immediately begged her to let him illustrate her songs and do a poster for her. At first she refused politely since she was not happy with the drawings he had done of her, but eventually she gave in and it was decided that Lautrec would illustrate an album written by the art critic Gustave Geffroy (see No. 435). The change in the tone of her letters to him shows how their relationship developed.

'July 1894.
Monsieur,
I should be very happy to see your posters. I shall be at home on Thursday at half past seven or on Saturday at two o'clock.
With thanks, Yvette Guilbert.'

A few days later:

'Cher Monsieur,
As I told you, my poster for this winter has been commissioned and is almost finished. So we shall have to put it off to another

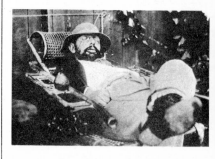

*The artist as eccentric:* (left) *a photograph taken in about 1892 shows Lautrec posing with mock solemnity in Japanese dress, squinting into the camera;* (right) *the foreshortened recumbent form of the artist asleep (taken in about 1896).*

time. But for heaven's sake don't make me so hideously ugly! A little less so . . . ! So many people who've been here have screamed with horror at the coloured sketch.

Not everyone is only interested in the artistic side – I should think not!

A thousand thanks,

Your grateful Yvette.'

Then Geffroy's book was published.

'1894

Cher Ami,

Thank you for your nice illustrations for Geffroy's book . . . I am really pleased and must thank you. Are you in Paris? If so come to lunch next week at my new address, 79 Avenue de Villiers.

With kind regards and again thanks,

Yvette.'

Lautrec illustrated one of Yvette's songs, Maurice Donnay's 'Eros Vanné'.

'Cher Ami,

Eros Vanné is wonderful. I'm absolutely thrilled. Carry on the good work, young man.

Seriously though, I am delighted and thank you over and over again.

Kindest regards,

Yvette.'

Lautrec also tried his hand at pottery and decorated a bookbinding and some glass for Tiffany, all with equal success. Yvette Guilbert was portrayed on the pot and when he showed it to her before firing she scrawled on it the words *'Petit monstre! Mais vous avez fait une horreur!!'* Four years later he illustrated another album for her, this time to appear in England, and she agreed to sign the lithographic stone for the fly-leaf.

On the strength of Yvette Guilbert's reputation the book by Geffroy and Lautrec was widely reviewed and to her astonishment highly praised on the front page of the *Figaro*, and in articles by Arsène Alexandre in *Paris* and Clemenceau in *La Justice*. Geffroy was a well-known art critic and he and Roger Marx in 1893 were the first to recognize Toulouse-Lautrec's outstanding talent. This was all the more remarkable as the press in general dismissed his painting as trite and sensational, a view which persisted long after his death.

On 13 February 1893 Roger Marx wrote:

'It is a long time since an artist as gifted as

*Lautrec's signature from the paintings here numbered 49 and 525 and dated 1895 and 1896 respectively.*

Monsieur de Toulouse-Lautrec has appeared. His strength perhaps lies in the harmony between his different talents – between his keen analysis and sureness of expression . . . Although at first his approach perhaps recalled Forain or Degas, M. de Toulouse-Lautrec soon freed himself from their influence and developed his own completely individual style.

With the confidence and strength of purpose of an artist who knows he is a true original M. de Toulouse-Lautrec is confidently fulfilling the promise of his early work.'

On 15 February 1893 Gustave Geffroy also reviewed the exhibition Joyant had organized:

'Toulouse-Lautrec emerges as an artist of confident judgement with an established style which will certainly develop in his own secret way.

In his paintings and pastels Toulouse-Lautrec with his use of colour, sometimes muted and rich, sometimes dark and murky, as the case may be, is equally adept at bringing a character to life, capturing a pose or movement, a woman walking or a dancer whirling round in the waltz.

Lautrec approaches dance halls, brothels and unnatural *ménages* with mocking humour and cruel but uncensorious insight. Yet he is always essentially an artist and his probing eye finds beauty in what he sees. The power of his art and the seriousness of his purpose

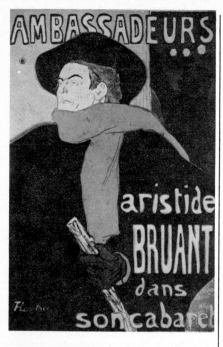

make the philosophy of vice which he sometimes flaunts a clinical instrument of sober moral analysis.'

For five years Lautrec was master of his art. He maintained his considerable output and continued to live an increasingly hectic life. He produced over a hundred pictures a year – paintings, posters, lithographs, newspaper illustrations and theatre programmes, besides countless drawings. He now had a set approach to his work. Wherever he was – in the street, café, theatre or brothel, at friends' houses or at his mother's, or on his travels, he made drawings of anything that caught his

*Aristide Bruant, the cabaret entertainer and song-writer, was Lautrec's friend, admirer and supporter. He published drawings by Lautrec as illustrations for his songs in the magazine* Le Mirliton, *named after his night-club. In 1892 he commissioned the Ambassadeurs poster.*

*The 1893 poster of Jane Avril at the Jardin de Paris, one of Lautrec's most famous, is clearly based on this photograph and on painting No. 399. After 1890 Lautrec concentrated increasingly on graphic art, producing posters and illustrations.*

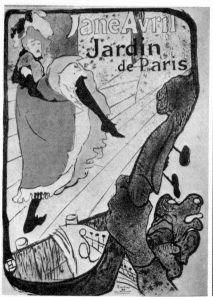

eye. For all his work, apart from his paintings, he made preliminary drawings, and often traced off copies to make alterations or try out different colours. Sometimes he used photographs to experiment with tone. He would produce a final draft before transferring the drawing to the lithographic stone, a job he always did himself. He also always supervised the printing. Sometimes the preparatory work might be a rapid sketch, showing his flair for capturing essentials with a few splashes of colour, as in the first study for the lithograph 'A Passing Fancy' in the series *Elles*

(No. 526). Sometimes he produced something more elaborate, like the second study for the same lithograph (No. 525). Even the simplest of lithographs involved endless drawings, tracings, water colour and oil studies. Lautrec worked in his studio, usually with a model, though for theatre and dance-hall scenes he often worked from sketches or from memory.

Lautrec immortalized one unremarkable singer, May Belfort, who had taken his fancy, in a number of paintings of her performances (Nos 494–7) and a series of lithographs, and he also tried to win her over with a poster (see No. 498). He also produced a poster of May Milton (No. 479), another plain and rather stupid singer and dancer who was a close friend of Jane Avril, her only claim to fame, since she danced only one season in Paris and then disappeared from the scene. Loïe Fuller, a dancer from the United States who was a great success in Paris with her veil dances lit by multicoloured spot-lights, was another of Lautrec's favourites and he produced a lithograph of her (No. 388), colouring each print by hand to capture the light and colour of her dance. Lautrec was continually fascinated also by dramatic actors and made many lithographs of them, choosing as his subjects those who appealed to him rather than established stars, and his work has saved many unknowns from lasting obscurity.

When Maurice Joyant organized an exhibition of Lautrec's work in London in 1898 he had a chance to visit the National Gallery again and study the Velazquez paintings there. He also visited the British Museum where he admired the Elgin Marbles for their life and vigour and the Greek statues of women. On a previous visit to London, in 1895, he met Oscar Wilde who made a strong impression on him, though they were fundamentally incompatible. Lautrec was physically handicapped but his cast of mind and personal mores were always straightforward and robustly masculine, whereas Oscar Wilde, a larger-than-life figure of scintillating wit, was of course a notorious homosexual. Lautrec accurately captured his character in a portrait (No. 483).

The Natanson brothers were constantly on the look-out for new writers and artists for their new magazine *La Revue Blanche* started in 1891. Their friends included Vuillard and Vallotton. Thadée Natanson's wife, Misia, a famous beauty, presided over their circle and acted as Lautrec's model for his poster for *La Revue Blanche* (No. 478). At the Natansons' he met Tristan Bernard, the writer, and struck up a fruitful friendship with him. At this time Bernard ran a bicycle-racing stadium, a sport then in its infancy and as usual Lautrec was fascinated by this new world. He sketched the riders and their trainers from every angle and

*Two of Lautrec's posters:*
(left) Moulin Rouge: La Goulue *(1891)*; (right) Troupe de Mlle Eglantine *(1896)*.

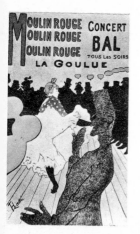

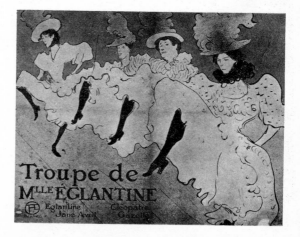

produced a poster, *La Chaîne Simpson*, for a friend who owned a bicycle company.

In 1896 Lautrec set off from Le Havre with his friend Maurice Guibert to travel to Bordeaux and on to Arcachon where he usually spent the summer. He then joined his mother at Malromé, in the Bordelais, where she had bought a château after family affairs had forced her to sell Céleyran. Well-supplied with port and wine he journeyed to Lisbon and then on to see the museums in Toledo and Madrid, which he later visited again. He returned full of enthusiasm for El Greco, Velazquez and Goya, but his search for local colour in the slums and seedier haunts of Spain had sickened him and on the whole the trip was not a success – apart, that is, from his memory of a beautiful stranger, a fellow passenger on his boat. He made a colour lithograph of her sitting in a deck chair gazing at the horizon and adapted it into a poster for the Salon des Cent.

Lautrec only really cared for Paris and was delighted to get back and resume his life of night-time drinking bouts and days spent working in his studio. On the strength of his album for Yvette Guilbert, Clémenceau asked him to illustrate a book for him, *Au pied du Sinai*, and Jules Renard, whom he had met at *La Revue Blanche*, asked him to illustrate his *Histoires Naturelles*, twenty-three pieces about animals, bringing back memories of his childhood in the country and long walks at the zoo. This was the last note of freshness in Lautrec's work, which was already overshadowed by the effects of his dissipated life and general disregard for his own well-being.

One morning in February 1899 he suffered a complete breakdown and had to be sent for treatment to a nursing home at Neuilly. Sanière, Joyant, Gabriel and his other friends rallied round. They tried to keep him out of trouble and organized trips to the country for him, but it was no use. As soon as he was left alone he would immediately start drinking again. After a few days in the nursing home he wrote to Maurice Joyant:

17 March 1899

Dear Sir [in English in the original],
Thanks for your kind letter. Come and see me.
Bis repetita placent.
Yours, T.L.

Send me some stones, a box of water colours, sepia, brushes, litho crayons, some good Indian ink and paper.
Come soon.

Joyant hurried to Neuilly and there, walking in the gardens, Lautrec asked for his help. 'If I can do enough drawings they won't be able to keep me here. I want to get out and they can't keep me locked up.' He produced an impressive series of circus drawings entirely from memory and won his release on 20 May after a three-month stay. 'I bought my freedom with my drawings,' he used to boast.

But time was short. His work took a surprising new turn, seen in his portrait of the Le Havre barmaid and his painting of the modiste, which were full of the calmness of his early work. During his last stay in Bordeaux he went as usual to the theatre and painted a series of scenes from *Messaline* (Nos 612–17) which reveal a new approach and give some idea of how his work was developing, as do his portraits of his friend Joyant (Nos 610–11), and of Mme Poupoule at her toilet (No. 586), and his scenes of riders in the Bois de Boulogne (Nos 627–8).

He returned to Paris where he produced his last poster, *La Gitane* (No. 626), for his friend Antoine, and then sank back into the round of bars and drinking. In July 1901 he left for Arcachon but his strength was failing and he was exhausted by the time he reached his mother's house at Malromé on 20 August. He went on working, drawing and writing, and died completely lucid on 9 September 1901 at the age of thirty-seven.

At his mother's request Joyant offered Lautrec's paintings to the Louvre but they refused them and it was twenty years before the Musée Toulouse-Lautrec in Albi opened. Yet today Toulouse-Lautrec is arguably the most popular painter in the world. Restaurants and bars are called after him from New York to Tokyo and reproductions of his work are found in the most unlikely places, on consumer goods such as ash-trays and glasses, tea-towels and cigarette lighters. This is true of no other artist and there is a pleasing irony to it – that Toulouse-Lautrec, who always wanted to bring art out into the streets, should have earned himself this honour after his death.

# Catalogue of the Paintings

After Lautrec's death Joyant stamped a number of unsigned paintings with a red seal of the painter's monogram in a circle. In the catalogue the term 'red seal' refers to these paintings.
All measurements are in centimetres.
s.d. = signed and dated.

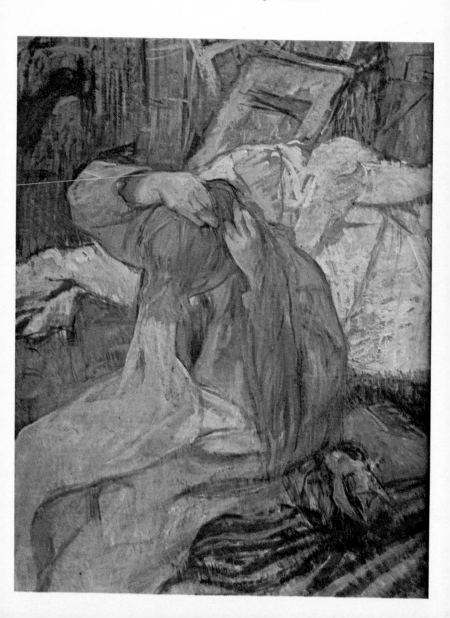

**Woman combing her Hair (No. 334).** (p. 11)
*Several of Lautrec's paintings show a model doing her hair in his studio. From this period, until his last works ten years later, he was constantly trying to find ways of capturing movement in his work.*

**318 Woman curling her Hair**
Cardboard/54 × 36.5/s. 1891
Toulouse, Musée des Augustins
Study for No. 319

**319 Two Women in their Chemises**
Cardboard/62 × 46/s.d. 1891
São Paulo, Museu de Arte

**320 Portrait of Dr Henri Bourges**
Cardboard/79 × 50.5/ s.d. 1891
Pittsburgh (USA), Museum of Art, Carnegie Institute

**321 Portrait of Georges-Henri Manuel, standing**
Cardboard/88 × 51/s.d. 1891
Zurich, Bührle Collection

**322 Portrait of Georges-Henri Manuel, seated**
Cardboard/45 × 48.5/s. 1891
Private collection

**323 Désiré Dihau reading a Paper**
Cardboard/56 × 45/1891
Albi, Musée Toulouse-Lautrec

**324 Portrait of Désiré Dihau**
Wood/35 × 27/1891
Albi, Musée Toulouse-Lautrec

**325 Portrait of Henri Dihau**
Cardboard/42 × 30.3/s. 1891
Albi, Musée Toulouse-Lautrec

**326 Portrait of M. Lemerle**
Canvas/80 × 63/s.d. 1891
Columbus (USA), Gallery of Fine Arts, Howald Fund

**327 Portrait of Paul Sescau**
Cardboard/82.5 × 35.6/ s.d. 1891
New York, Brooklyn Museum

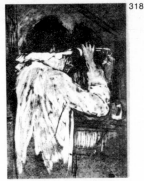
318

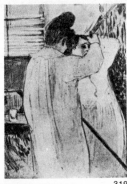
319

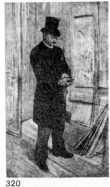
320

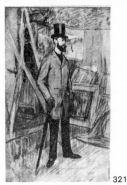
321

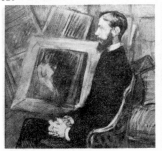
322

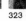
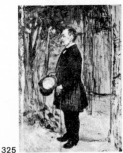
323

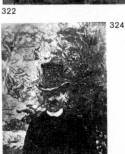
324

325

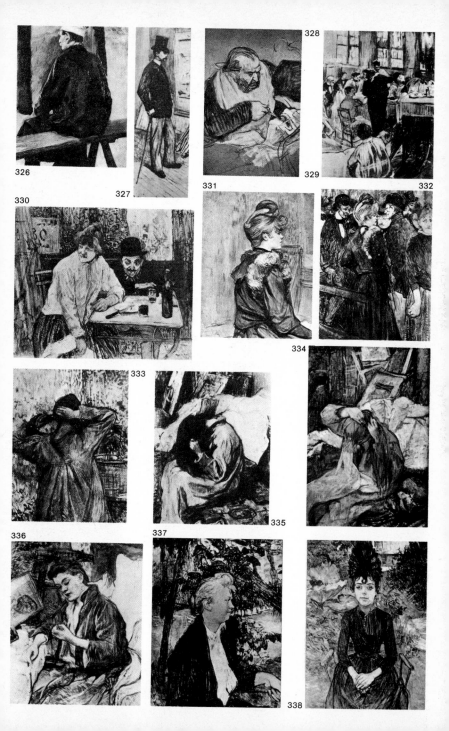

326

327

328

329

330

331

332

333

334

335

336

337

338

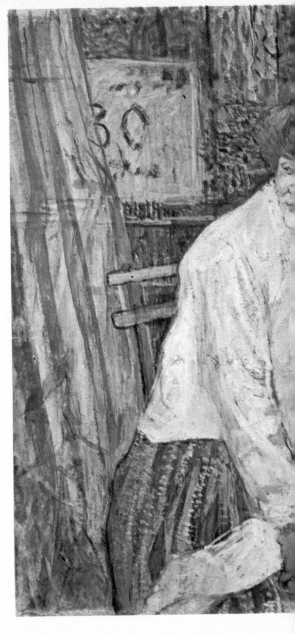

*'A la mie' (No. 330).*
*The man leaning on the table is Maurice Guibert, a friend of Lautrec, whose sardonic, worldly face often appears in his paintings. A champagne salesman and bon vivant, he was always to be seen in the best Parisian night spots.*

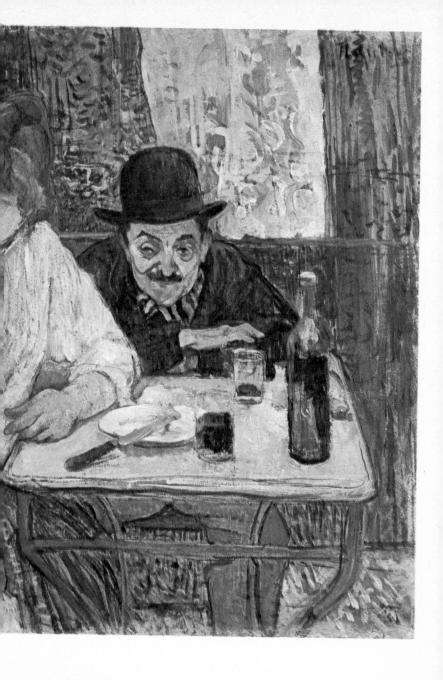

**339 Woman with a Dog
(Madame Fabre at Arcachon)**
Cardboard/74 × 57/s.d. 1891
USA, private collection

**340 Seated Woman with
Gloves (Honorine Platzer)**
Cardboard/54 × 40/s. 1891
Paris, Musée du Louvre

**341 Woman with Gloves,
standing (Honorine Platzer)**
Cardboard/48 × 31/s. 1891
Private collection

**342 Woman seated in Forest's
Garden (Honorine Platzer)**
Cardboard/60.1 × 55/s. 1891
Toledo (USA), Museum of
Art

**343 La Goulue at the Moulin
Rouge with a Dancer**
Cardboard/80 × 65/s. 1891
Private collection

**344 La Goulue**
Cardboard/41 × 33/red seal/
1891
Private collection
Study for No. 345. There is a
study of just the face in a
private collection

**345 La Goulue and Valentin-le-
Désossé**
Canvas/154 × 118/1891
Albi, Musée Toulouse-
Lautrec
Study for the Moulin Rouge
poster

**346 Seated Woman Seen from
the Back**
Cardboard/62.5 × 47/red seal/
1891
Toulouse, private collection

339

340

341

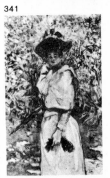

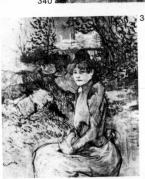

342

34

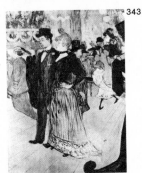

343

345

346

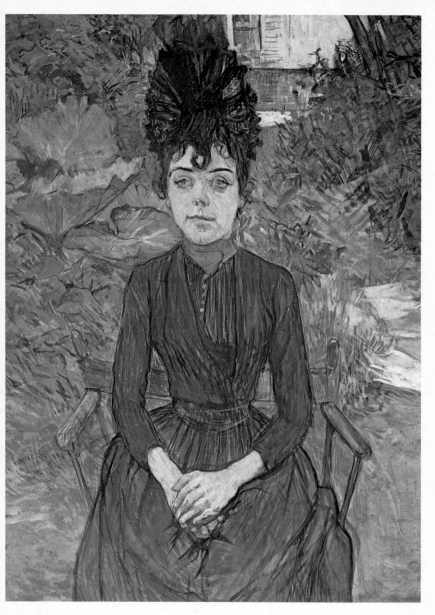

**Justine Dieuhl seated in Forest's Garden (No. 338).**
*Monsieur Forest's garden was close to Lautrec's studio, a stone's throw from the Place de Clichy. Lautrec often used it as a setting, and a number of other artists worked there too.*

**347 Redhead Seen from the Back with a Hat**
Cardboard/78 × 59.7/red seal/ 1891
Albi, Musée Toulouse-Lautrec

**348 Redhead Seen from the Back**
Cardboard/81.5 × 60.2/red seal/1891
Albi, Musée Toulouse-Lautrec

**349 At the Nouveau Cirque (Five Stuffed Shirts)**
Cardboard/59.5 × 40.5/s. 1891
Philadelphia (USA), Museum of Art, McIlhenny Fund

**350 Casque d'Or (The Streetwalker)**
Cardboard/64.7 × 53/s. 1891
USA, private collection

**351 Boulou**
Wood/25 × 18/s.d. 1891
Private collection

**352 Under the Pergola**
Wood/55 × 46/s. 1891
Private collection

**353 Portrait of Gaston Bonnefoy**
Cardboard/71 × 37/s. 1891
Private collection

**354 Bruant on his Bicycle**
Cardboard/74.5 × 65/red seal/ 1892
Albi, Musée Toulouse-Lautrec

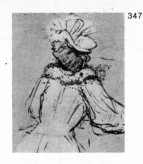

347

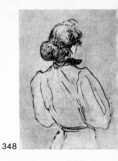

348

349

350

353

352

351

354

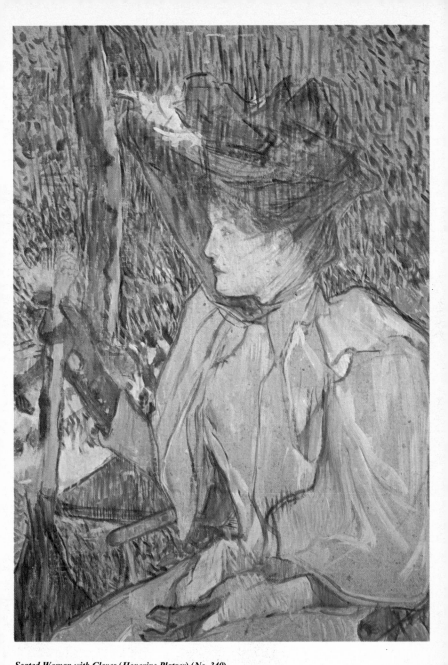

**Seated Woman with Gloves (Honorine Platzer) (No. 340).**
*Lautrec often painted portraits for his friends. In this case his subject is Honorine Platzer, shown sitting holding her gloves in her left hand and a parasol in her right, wearing a hat and veil. Another portrait shows her standing in Forest's garden, wearing the same costume.*

19

**355 Aristide Bruant in Cabaret at the Ambassadeurs**
Paper on canvas/255 × 120/ 1892
Albi, Musée Toulouse-Lautrec
Study for a poster which was never completed. There is also a sketch for the figure of Bruant in the museum

**356 Jane Avril leaving the Moulin Rouge**
Cardboard/84.3 × 63.4/s. 1892
Hartford (USA), Wadsworth Atheneum

**357 Jane Avril dancing**
Cardboard/84 × 44/s. 1892
Paris, Musée du Louvre
There is a study for this painting, showing just the dancer, in the Musée Toulouse-Lautrec, Albi

**358 Jane Avril entering the Moulin Rouge**
Cardboard/102 × 55/s. 1892
London, Courtauld Institute
There is a sketch showing the face almost in profile in the National Gallery, Washington

**359 Jane Avril: Bust Portrait facing Front**
Cardboard/63.2 × 42.3/s. 1892
Williamstown (USA), Sterling and Francine Clark Art Institute

**360 A Couple of Dancers at the Moulin Rouge**
Cardboard/80 × 65/1892
Private collection

**361 La Goulue entering the Moulin Rouge**
Cardboard/80 × 60/s. 1892
New York, Museum of Modern Art (David M. Lévy gift)

**362 At the Moulin Rouge: La Goulue and La Môme Fromage**
Cardboard/46.8 × 35.4/s. 1892
Philadelphia, Museum of Art (Chester Dale gift)
Study for a lithograph

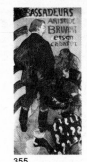
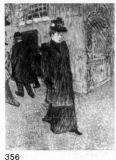
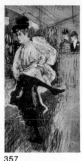

355    356    357

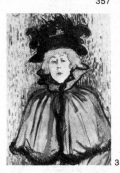
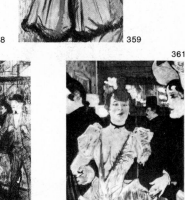

358    359

360    361

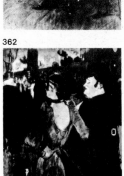
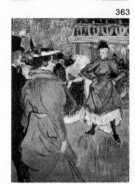

362    363

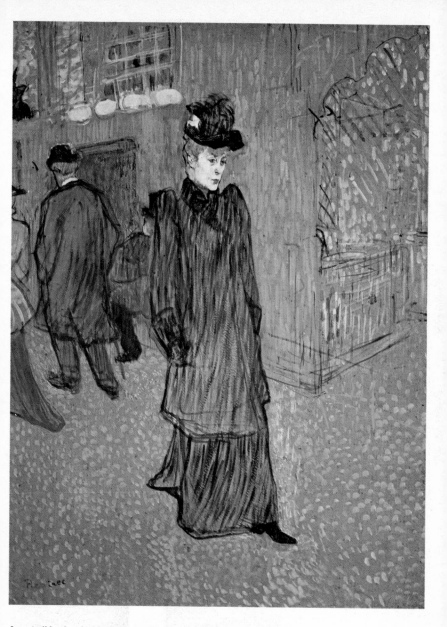

***Jane Avril leaving the Moulin Rouge (No. 356).***
*Jane Avril was by far Lautrec's favourite model and he was always extremely fond of her. The man in the background is the English painter Charles Conder, an habitué of the Moulin Rouge and Bruant's cabaret.*

**21**

**363 Preparing for the Quadrille at the Moulin Rouge**
Cardboard/79.5 × 60.2/red seal/1892
Washington, National Gallery (Chester Dale Collection)

**364 The Englishman at the Moulin Rouge**
Cardboard/86 × 66/s. 1892
New York, Metropolitan Museum of Art
Study for the poster. There is a sketch of the Englishman's head in the Musée Toulouse-Lautrec, Albi

**365 The Promenade at the Moulin Rouge**
Canvas/123.5 × 141/red seal/1892
Chicago (USA), Art Institute (Helen Birch Bartlett gift)

**366 At the Moulin Rouge: Two Women waltzing**
Cardboard/95 × 80/s.d. 1892
Prague, Národní Galerie

**367 A Corner of the Moulin de la Galette**
Cardboard/100 × 89/s. 1892
Washington, National Gallery of Art (Chester Dale Collection)

**368 The Ballet of Papa Chrysanthème**
Cardboard/61 × 80.6/red seal/1892
Albi, Musée Toulouse-Lautrec

**369 The Ballet of Papa Chrysanthème**
Cardboard/65 × 58.3/red seal/1892
Albi, Musée Toulouse-Lautrec

**370 Portrait of Monsieur X**
Cardboard/58 × 49/red seal/1892
Albi, Musée Toulouse-Lautrec

**371 At the Masked Ball (Parisian Fêtes; Nouveaux Confetti)**
Paper/37.5 × 49/s. 1892
Private collection

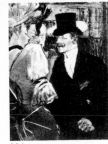
364

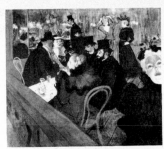
365

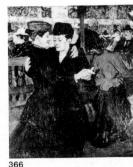
366

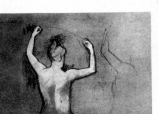
367

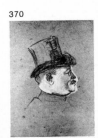
368

369

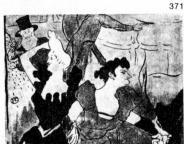
370

371

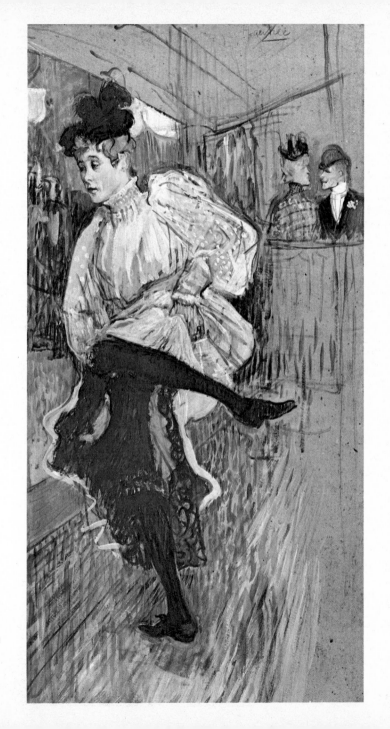

23

**372 Woman in a Black Boa**
Cardboard/52 × 41/s. 1892
Paris, Musée du Louvre

**373 The Kiss**
Cardboard/39 × 58/s. 1892
Paris, private collection

**374 In Bed**
Cardboard/53 × 34/s. 1892
Zurich, Bührle Collection

**375 In Bed: the Kiss**
Cardboard/42 × 56/1892
Paris, Goldschmidt-
Rothschild Collection

**376 In Bed**
Cardboard/54 × 71/s. 1892
Paris, Musée du Louvre

*Decorations for the Salon of
the* Maison *in Rue d'Amboise*
(Nos. 377–8)

**377 Panel with Medallion**
Wood/height 180 cm/1892
The brothel decorations
consisted of sixteen panels,
each containing a medallion.
They were cut down and
dispersed after 1930

**378 Panel with Medallion**
Wood/height 180 cm/1892
See previous entry

\*

**379 Woman Seen from Behind**
Cardboard/60.5 × 39.5/red
seal/1892
Upperville (USA), Mellon
Collection

**380 The 'Divan japonais'**
Cardboard/28 × 35/s. 1892
France, private collection
There is a less finished study
for the same poster in a
private collection

*Jane Avril dancing (No. 357).*
(p. 23)
*Unlike La Goulue, who
appeared in the quadrille, Jane
Avril (nicknamed La
Mélinite) preferred to dance
alone. Her performance was
immortalized by Lautrec.*

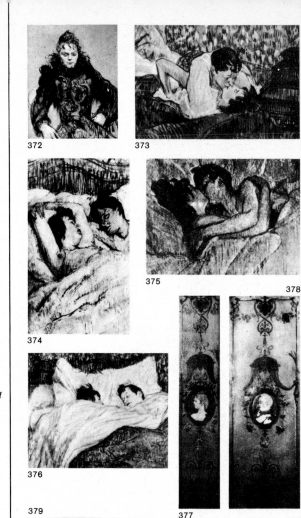

372    373

375

378

374

376

379

377    380

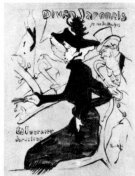

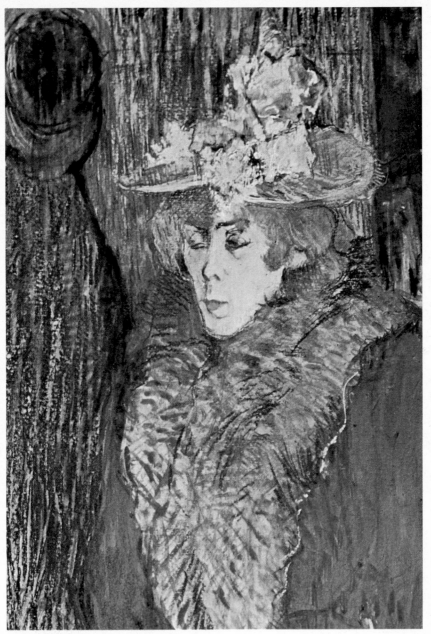

*Jane Avril entering the Moulin Rouge (No. 358; detail).*
*Lautrec gave his favourite model many of his paintings, but Jane Avril was notoriously fickle. She had a*
*succession of lovers and when she moved on would leave everything behind, including her paintings. By the time*
*of Lautrec's death she no longer had a single one of his works.*

**25**

**381 The Street-walker**
Cardboard/53 × 42/s.d. 1892
New York, private collection

**382 Head of a Woman**
Cardboard/39 × 37/s. *c.* 1892
Paris, private collection

**383 Portrait of Henri Gabriel Ibels**
Cardboard/54.5 × 42.5/s. 1893
USA, private collection

**384 Portrait of Delaporte**
Cardboard/76 × 70/s. 1893
Copenhagen, Ny Carlsberg Glyptotek

**385 M. Boileau at the Cafe**
Canvas/80 × 65/s. 1893
Cleveland (USA), Museum of Art

**386 Louis Pascal Seen from Behind**
Cardboard/65 × 40.5/s. 1893
São Paulo, Museu de Arte

**387 Louis Pascal in Profile**
Cardboard/77 × 53/s. 1893
Albi, Musée Toulouse-Lautrec

**388 Loïe Fuller at the Folies-Bergère**
Cardboard/63.2 × 45.3/s. 1893
Albi, Musée Toulouse-Lautrec
Study for a lithograph

381

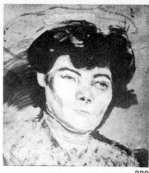

382

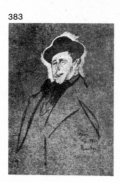

383

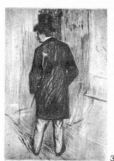

384          385

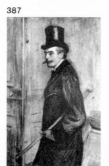

387

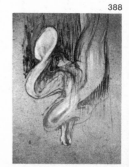

386

388

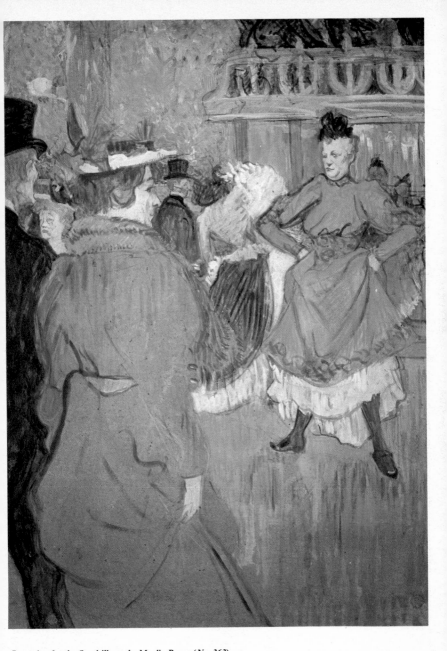

***Preparing for the Quadrille at the Moulin Rouge*** (*No. 363*).
*The quadrille was based on the can-can. La Goulue, Nini Patte-en-l'air, Grille d'Egout, Cha-U-Kao, La Môme Fromage, La Sauterelle and others took it in turns to perform the high-kicking antics it demanded.*

**27**

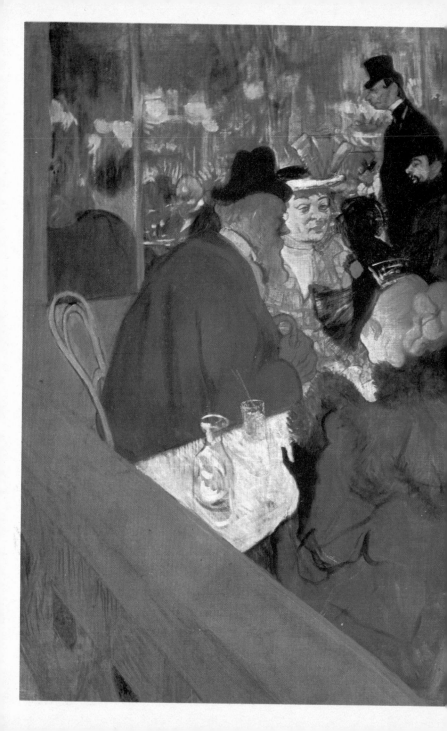

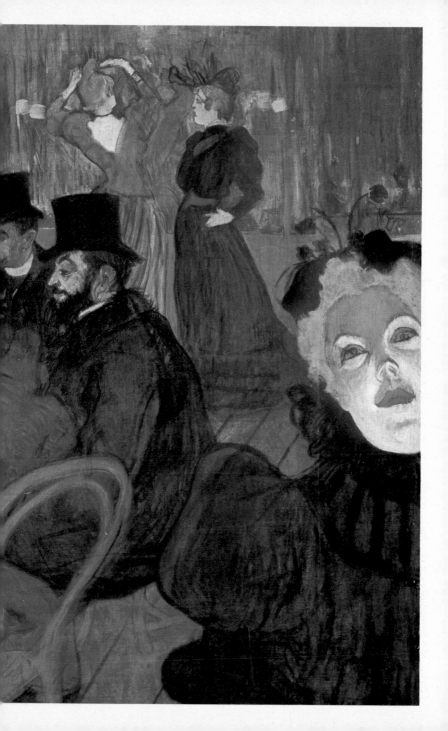

**389 Naked Girl**
Cardboard/59 × 39/s. 1893
Albi, Musée Toulouse-
Lautrec
Study for a lithograph to
illustrate Sombre's poem
*Etude de Femme*

**390 The Box at the Mascaron
Doré**
Canvas/40.8 × 32.4/red seal/
1893
Albi, Musée Toulouse-
Lautrec
Study for a lithograph for the
programme of Marcel Luguet's
play *Le Missionnaire*

**391 The Box at the Mascaron
Doré**
Cardboard/32 × 24/1893
Private collection
See previous entry

**392 Caudieux, Café-concert
Actor**
Cardboard/68 × 48/s. 1893
Private collection
Illustration for Geffroy's 'Le
Plaisir à Paris: Les
restaurants et les cafés-
concerts des Champs-
Elysées', as are Nos 395, 397,
398 and 400. There is a sketch
in the Musée Toulouse-
Lautrec, Albi

**393 Caudieux**
Paper/114 × 88/1893
Albi, Musée Toulouse-
Lautrec

**The Promenade at the Moulin
Rouge (No. 365).** (pp. 28–29)
*La Goulue is standing in the
background doing her hair.
Sitting round the table are
Lautrec's friends; the
photographer Sescau, Edouard
Dujardin and Maurice
Guibert, with the Spanish
dancer, La Macarona. Lautrec
and his cousin Gabriel Tapié
de Céleyran are walking past
in the background.*

389

391

393

395

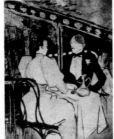

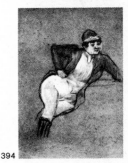

390

392

394

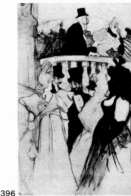

396

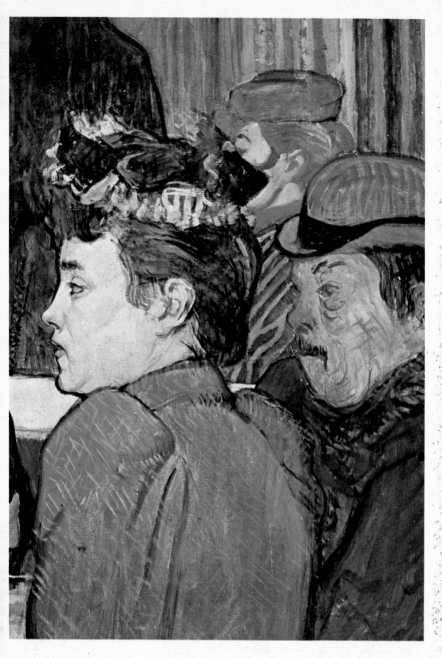

***A Corner of the Moulin de la Galette*** (*No. 367; detail*).
*During 1891 and 1892 Lautrec was particularly interested in dance halls and cabarets, concentrating above all on facial expression and pose.*

**394 La Macarona dressed as a Jockey**
Cardboard/52 × 39/s.d. 1893
Chicago (USA), Art Institute (Mary and Leigh B. Block gift)
The corresponding painting, used as an illustration for Geffroy's 'Le Plaisir à Paris: Les bals et le carnaval', is in a private collection. (See also Nos 396, and 443–6)

**395 Smart Folk at the Ambassadeurs**
Cardboard/85 × 65/s. 1893
Upperville (USA), Mellon Collection
Illustration, see No. 392

**396 At the Bal de l'Opéra**
Cardboard/78.7 × 50.8/ s.d. 1893
Private collection
Illustration, see No. 394. There is a sketch of the woman's figure seen from behind and another of the composition as a whole in private collections

**397 At the Entrance of the Ambassadeurs**
Cardboard/64 × 48/s. 1893
Private collection
Illustration, see No. 392

**398 M. Prince, Café-concert Actor**
Cardboard/52 × 39/s. 1893
Private collection
Illustration, see No. 392

**399 Jane Avril dancing**
Cardboard/101 × 75/1893
Athens and Paris, Stavros Niarchos Collection
Study for a poster

**400 'La Roue'**
Cardboard/62 × 47.5/s. 1893
São Paulo, Museu de Arte
Illustration, see No. 392. There is another study of the same subject in a private collection

**401 Jane Avril**
Cardboard/66.8 × 52.2/red seal/1893
Albi, Musée Toulouse-Lautrec

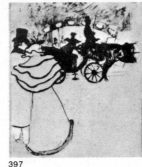

397

398

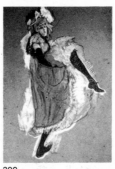

399

400

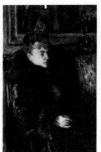

402

403

404

401

405

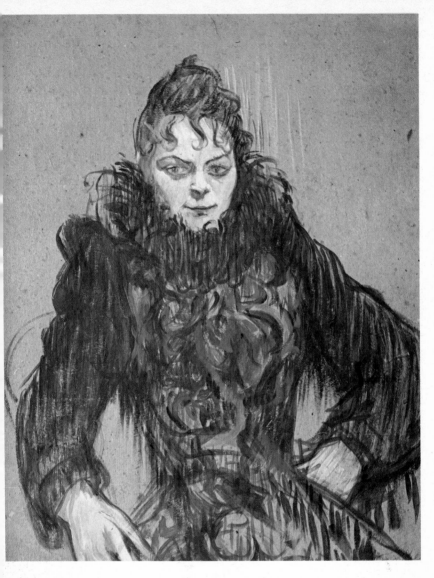

**Woman in a Black Boa** (No. 372).
*Despite opposition from Bonnat, his former master, this was the first of Lautrec's paintings to be hung in the Louvre, the year after his death.*

**402 Profile of a Woman (Jane Avril)**
Cardboard/129 × 50/1893
Private collection

**403 Portrait of Madame Gortzikoff**
Cardboard/76 × 51/1893
Private collection

**404 At the Cirque Médrano (Boum-Boum)**
Cardboard/56 × 37/s. 1893
USA, private collection

**405 At the Cirque Médrano: Trapezist**
Cardboard/80 × 60/s. 1893
Cambridge (USA), Fogg Art Museum, Harvard University

**406 Crouching Woman**
Cardboard/34.6 × 53.2/red seal/1893
Albi, Musée Toulouse-Lautrec

**407 Seated Woman**
Cardboard/57 × 44/s. 1893
Albi, Musée Toulouse-Lautrec

**408 'Pauvre Pierreuse'**
Cardboard/36 × 26/s. 1893
USA, private collection
Study for a lithograph

**409 Mère Capulet**
Canvas/80 × 65/red seal/1893
Private collection
Set for Messager's *Les Amants eternels*

**410 Monsieur, Madame and their Little Dog**
Canvas/48 × 60/red seal/1893
Albi, Musée Toulouse-Lautrec

**411 On the Staircase at Rue des Moulins**
Cardboard/67 × 53/1893
Paris, private collection

**412 At the Top of the Staircase at the Rue des Moulins: Come on up!**
Cardboard/82.5 × 60/red seal/1893
Albi, Musée Toulouse-Lautrec

406

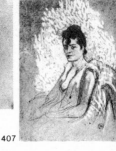

407

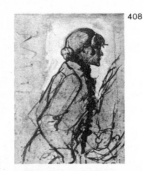

408

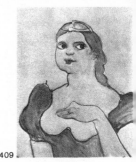

409

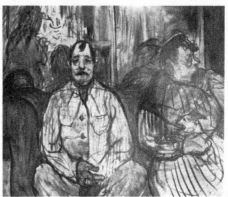

410

411

412

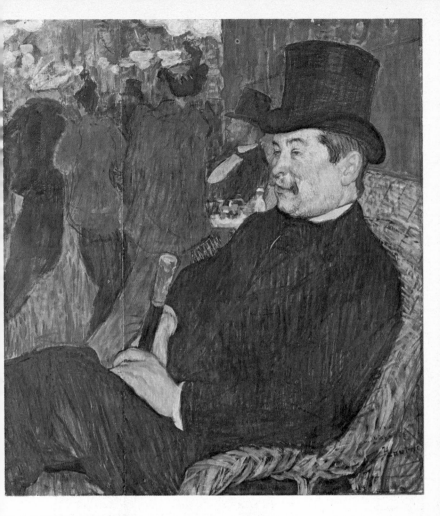

**Portrait of Delaporte** (*No. 384*).
*Delaporte ran an advertising and poster agency. in 1905 the Friends of the Musée du Luxembourg offered this painting to the French government, which refused it. It now hangs in the Carlsberg Museum in Copenhagen.*

*413 On the Staircase of the Brothel*
Cardboard/75 × 55/1893

*414 Prostitutes*
Cardboard/60 × 48.5/s. 1893
Cap Martin, Reves Collection

*415 The Dining-room at the Brothel*
Wood/61 × 81/s. 1893
Budapest, Szépmüvészeti Múzeum

*416 In the Salon*
Cardboard/51.5 × 78.5/s. 1893
New York, Salomon R. Guggenheim Museum

*417 Woman in a Bath-robe playing Cards*
Cardboard/64 × 49/1893
France, private collection
Study for No. 418

*418 In the Salon: the Divan*
Cardboard/60 × 80/s. 1893
São Paulo, Museu de Arte

*419 Two Women making their Bed*
Cardboard/61 × 80/s.d. 1893
Private collection

*420 The Streetwalker Gabrielle*
Cardboard/60 × 50/s. 1893
Private collection

413

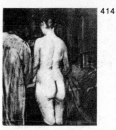

414

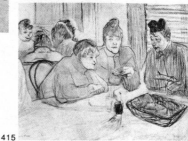

416

415

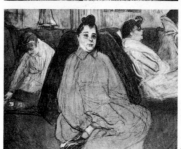

417

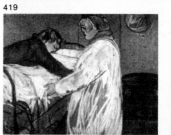

419

418

420

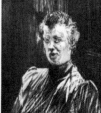

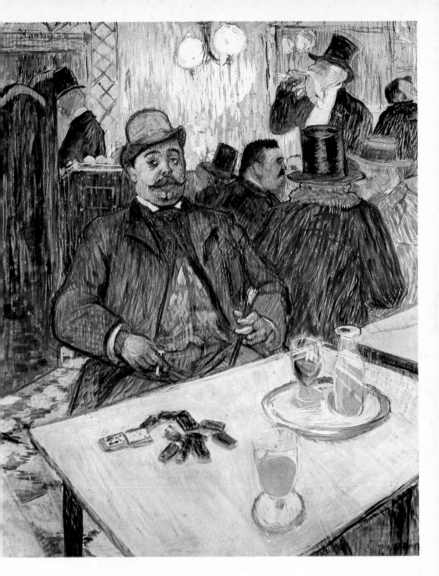

**M. Boileau at the Café** (*No. 385*).
*Monsieur Boileau was a* bon vivant *and café-goer. The glass in the foreground appears to belong to a companion who is out of the picture, and is perhaps Lautrec himself.*

**421 The Card Game**
Cardboard/57.5 × 46/s. 1893
Switzerland, private
collection

**422 The Coiffure**
Cardboard/36 × 27.5/1893
Private collection
Study for a lithograph

**423 Woman at her Window**
Cardboard/58.5 × 46.6/s. 1893
Albi, Musée Toulouse-
Lautrec

**424 Day Out**
Cardboard/40 × 30/red seal/
1893
London, Harari Collection

**425 Prostitute**
Cardboard/63 × 48/s. 1893
Private collection

**426 Prostitute pinning up her
Chignon**
Cardboard/65 × 31/s. 1893
Private collection

**427 At the Foot of the
Scaffold**
Cardboard/73 × 59/red seal/
1893
Private collection
Study for a poster

**428 Cormorant on a Boat**
Cardboard/41.5 × 27.5/s. 1893
Nancy, Musée Lorrain
Study for the cover of
Lecomte's *Arte impressioniste*

421

422

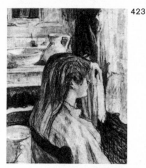

423

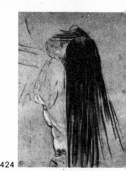

424

425

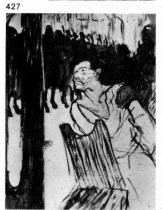

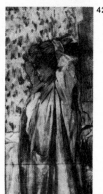

426

427

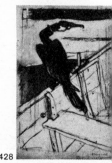

**Louis Pascal in Profile
(No. 387).**
*Louis Pascal, Lautrec's
cousin, leaving the painter's
studio.*

428

**Loïe Fuller at the Folies-Bergère (No. 388).**
*Loïe Fuller was an American girl famous for her veil dance performed under revolving, multi-coloured lights. She was a great success, first in the States, then in Paris. This painting is a study for a lithograph of the same subject.*

***The Box at the Mascaron Doré*** (*No. 391*).
*One of two studies for an illustration for the programme of Marcel Luguet's play* LE MISSIONNAIRE.

**429 Crab in the Sand**
Cardboard/26 × 24/s. 1893
Nancy, Musée Lorrain
As above

**430 Crab eating a Skate**
Cardboard/25 × 20/s. 1893
Nancy, Musée Lorrain
As above

**431 Loïe Fuller in the Ring**
Paper/49 × 56/c. 1893
Private collection

**432 Portrait of the Artist
Charles Conder**
Cardboard/47 × 35.5/
s. c. 1893
Private collection

**433 Alfred la Guigne**
Cardboard/65 × 50/s. 1894
Washington, National
Gallery (Chester Dale
Collection)

**434 Confetti**
Canvas/55.5 × 43/s.d. 1894
Zurich, Bührle Collection
Study for a poster

**435 Yvette Guilbert's Black
Gloves**
Cardboard/62.8 × 37/s. 1894
Albi, Musée Toulouse-
Lautrec
For the cover of Yvette
Guilbert's album, text by
Geffroy

**436 Yvette Guilbert**
Paper/186 × 93/1894
Albi, Musée Toulouse-
Lautrec
Study for a poster which was
never completed

429

430

431

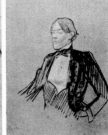
432

433

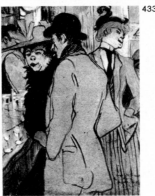

434
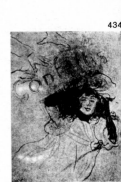

435

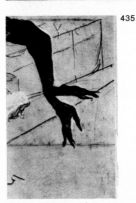

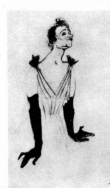
436

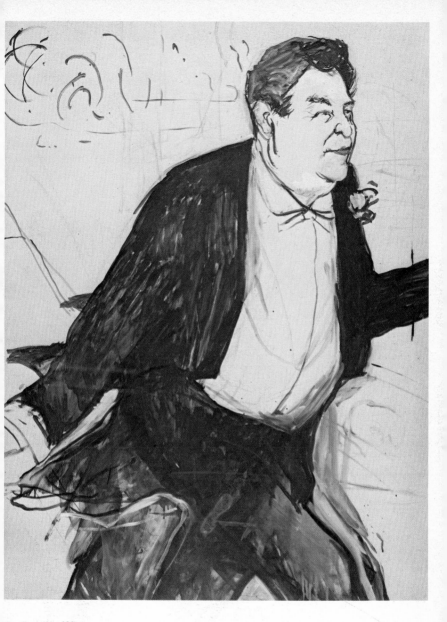

***Caudieux*** (*No. 393*).
*Study for a poster Lautrec painted in 1893 when the comedian, nicknamed the 'Homme Canon', was appearing at the Petit Casino.*

**437 Yvette Guilbert taking a Curtain Call**
Photographic enlargement of a lithograph drawing coloured with *peinture à l'essence*/48 × 28/s. 1894
Albi, Musée Toulouse-Lautrec

**438 Gabriel Tapié de Céleyran**
Canvas/110 × 56/1894
Albi, Musée Toulouse-Lautrec

**439 Yvette Guilbert singing 'Linger Longer Loo'**
Cardboard/58 × 44/s.d. 1894
Moscow, Pushkin Museum

**440 Woman in Evening Dress at the Door of a Box**
Canvas/81 × 51.5/1894
Albi, Musée Toulouse-Lautrec

**441 At the Folies-Bergère: Three Chorus-girls**
Cardboard/69 × 59/red seal/1894
Albi, Musée Toulouse-Lautrec

**442 The Flower-seller**
Cardboard/53 × 40.5/s. 1894
Albi, Musée Toulouse-Lautrec
Study for No. 443

**443 The Flower-seller**
On autotype paper mounted on cardboard/51 × 33.5/s. 1894
Private collection
Illustration, see No. 394

**444 At the Moulin Rouge**
Cardboard/54.5 × 43/s. 1894
Buenos Aires, Santa Marina Collection
Illustration, see No. 394

**445 Two Women waltzing**
Cardboard/60 × 40/s. 1894
Private collection
The corresponding painting used as an illustration (see No. 394) is in the Louvre

**446 Two Women at the Bar**
Cardboard/60 × 40/red seal/1894
Private collection
The corresponding painting used as an illustration (see No. 394) is in the Louvre

437

438

439

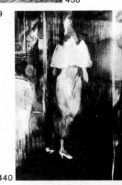

440

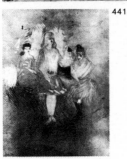

441

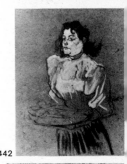

442

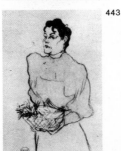

443

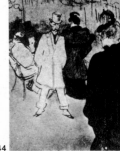

444

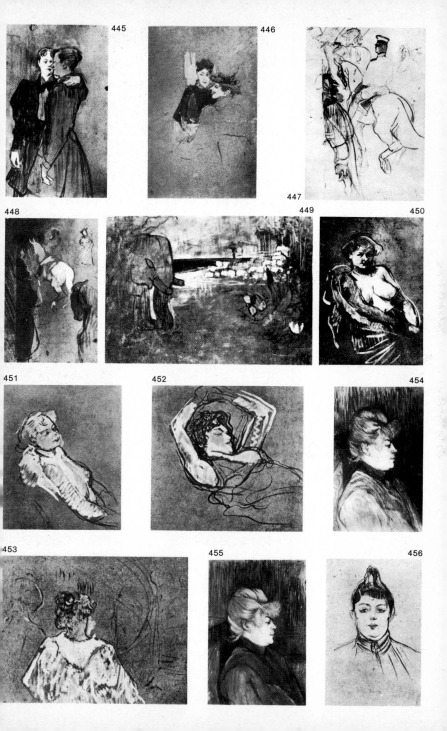

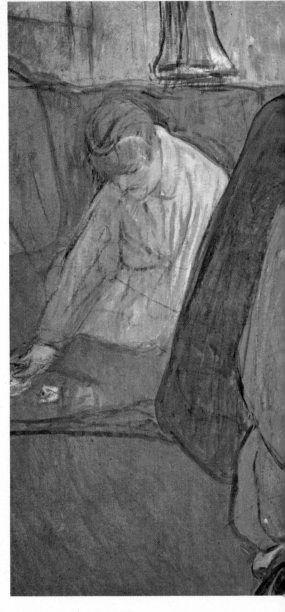

*In the Salon: the Divan (No. 418).*
*In the course of many extended visits to brothels Lautrec recorded every
aspect of the women's daily routine.*

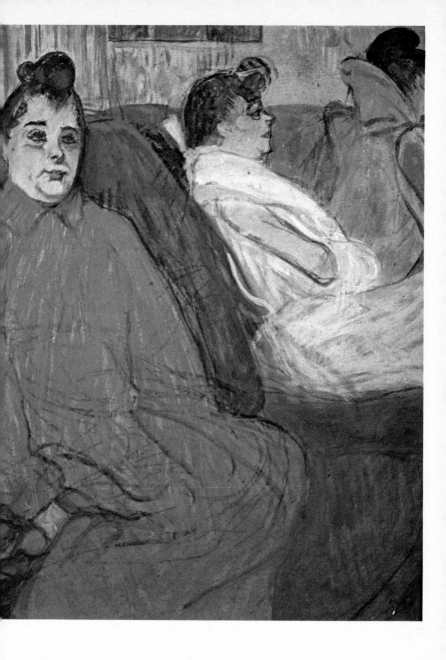

**457 Marcelle**
Cardboard/46.5 × 29.5/s. 1894
Albi, Musée Toulouse-
Lautrec
This painting was stolen at an
exhibition in Kyoto, Japan,
on 26 December 1968

**458 Prostitute**
Wood/22.5 × 16/s. 1894
Albi, Musée Toulouse-
Lautrec

**459 The Laundry-man at the
Brothel**
Cardboard/57.8 × 46.2/1894
Albi, Musée Toulouse-
Lautrec

**460 The Rue des Moulins:
Rolande**
Cardboard/51 × 70/s. 1894
Private collection

**461 The Divan: Rolande**
Cardboard/51.7 × 56.9/red
seal/1894
Albi, Musée Toulouse-
Lautrec

**462 In Bed**
Cardboard/52 × 67.3/red seal/
1894
Albi, Musée Toulouse-
Lautrec

**463 Rolande of the Rue des
Moulins**
Cardboard/48.5 × 34.5/s. 1894
Private collection

**464 The Friends**
Cardboard/48 × 34.5/s. 1894
Albi, Musée Toulouse-
Lautrec
There is another version of
this painting in the Tate
Gallery, London

**Yvette Guilbert taking a
Curtain Call (No. 437).**
*The famous* diseuse *Yvette
Guilbert, Lautrec's favourite
model after Jane Avril,
fascinated the artist with her
gestures and mobile,
expressive face. This painting
is a study for an illustration in
the album* YVETTE GUILBERT,
*written by the art critic
Gustave Geffroy who was
almost alone in recognizing
Lautrec's genius during his
life-time.*

457
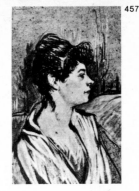

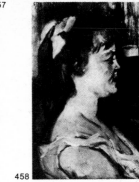
458

459

460

461
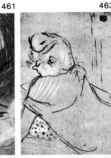

463
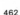

464
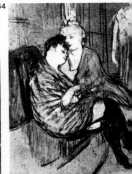

462
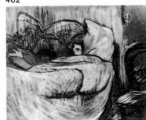

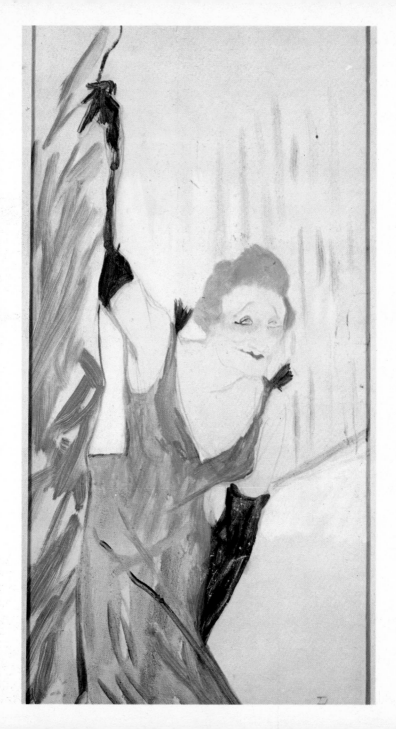

**465 Tattooed Woman**
Cardboard/62.5 × 48/s. 1894
Berne, private collection

**466 Woman putting on her Stocking**
Cardboard/61.5 × 44.5/s. 1894
Albi, Musée Toulouse-Lautrec
There is a version of this painting with an additional figure in the Louvre (Jeu de Paume), Paris

**467 Rue des Moulins: the Medical Inspection**
Cardboard/54 × 39/s. 1894
Albi, Musée Toulouse-Lautrec

**468 Rue des Moulins: the Medical Inspection**
Cardboard/82 × 59.5/1894
Washington, National Gallery (Chester Dale Collection)
There are two studies for this painting, one in the Louvre, Paris, the other in the Musée Toulouse-Lautrec, Albi

**469 In the Salon at the Rue des Moulins**
Canvas/69 × 40/s. 1894
Los Angeles (USA), Armand Hammer Collection
Study for No. 470

**470 In the Salon at the Rue des Moulins**
Canvas/111.5 × 132.5/s. 1894
Albi, Musée Toulouse-Lautrec
There is another study for this painting in this museum

**471 La Tauromachia**
Cardboard/55.5 × 72/s. 1894
Private collection
Study for the binding for Goya's *Tauromachia*

**472 Woman in a Green Cape**
Cardboard/51.5 × 38/red seal/
c. 1894
Private collection

***Gabriel Tapié de Céleyran (No. 438).***
*Lautrec's younger cousin, Gabriel Tapié de Céleyran, studied medicine in Paris. The two were very close and Gabriel's long-suffering affection for Lautrec made him more like a brother.*

465

466

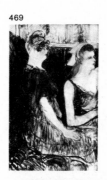

467

468

469

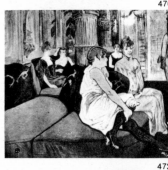

47

472

471

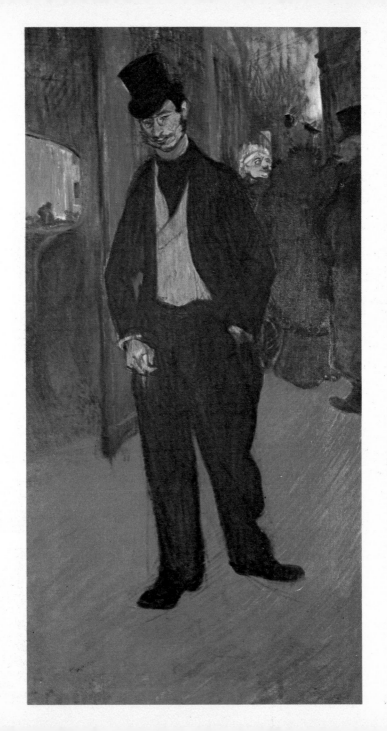

**473 Still Life**
Canvas/46 × 61/s. *c.* 1894
Basle, Staechelin Foundation

**474 Beauty and the Beast**
Cardboard/34 × 25/s. 1895
Buenos Aires, Santa Marina
Collection

**475 Beauty and the Beast: the
Game of Bezique**
Cardboard/32 × 24/s. 1895
Paris, private collection
Study for a lithograph

**476 Riders**
Canvas/65 × 40/1895
Albi, Musée Toulouse-
Lautrec
The top part of the painting
was done in about 1881

**477 A Meal at the Natansons'**
Cardboard/60 × 80/red seal/
1895
London, private collection

**478 Misia Natanson**
Cardboard/94 × 72/red seal/
1895
Athens and Paris, Stavros
Niarchos Collection
There is another study for
this poster, *La Revue blanche*,
in the Musée Toulouse-
Lautrec, Albi

**479 Miss May Milton**
Cardboard/49 × 31/red seal/
1895
England, private collection
Study for a poster

**480 Tristan Bernard at the
Buffalo Bicycle-racing
Stadium**
Canvas/64.5 × 81/1895
New York, private collection

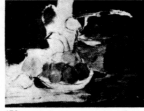

473

474

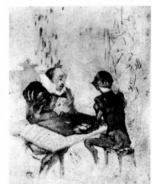

475

476

477

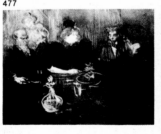

479

480

478

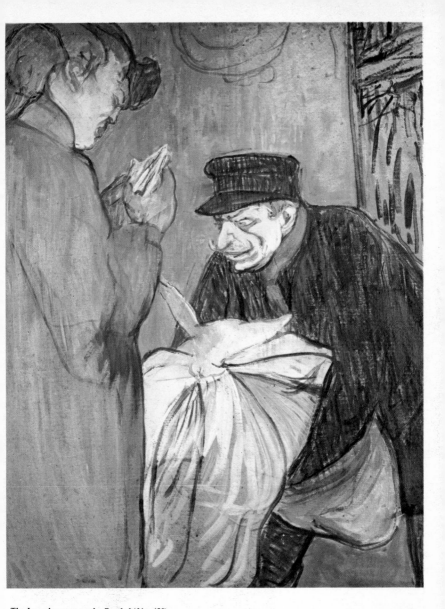

***The Laundry-man at the Brothel*** (*No. 459*).
*A painting of behind-the-scenes brothel life. Lautrec was on familiar terms with the women and able to explore all aspects of their off-duty existence as he pleased.*

53

**481 May Milton**
Cardboard/65 × 48/s. 1895
Chicago (USA), Art Institute
(Kate Brewster Bequest)

**482 Napoleon**
Cardboard/61 × 47/s. 1895
Zurich, Bührle Collection

**483 Portrait of Oscar Wilde**
Cardboard/60 × 50/s. 1895
Private collection

**484 Coachman to a High-class Family**
Cardboard/51.7 × 40.5/s. 1895
Albi, Musée Toulouse-Lautrec

**485 Lucien Guitry and Jeanne Granier**
Cardboard/55.5 × 43/red seal/1895
Albi, Musée Toulouse-Lautrec

**486 Lucien Guitry and Jeanne Granier, seated**
Cardboard/65 × 52/red seal/1895
USA, private collection

**487 Lad from a Racing Stable**
Cardboard/68 × 53/s. 1895
Albi, Musée Toulouse-Lautrec

**488 Mme Pascal playing the Piano**
Cardboard/71.2 × 54.5/s. 1895
Albi, Musée Toulouse-Lautrec
There is another portrait of Mme Pascal playing the piano in a private collection

**Woman putting on her Stocking (No. 466).**
*This picture is a good example of Lautrec's approach to his subject matter: he has captured a fleeting moment of elegant movement as the woman pulls up her stocking without a hint of prurience or vulgarity.*

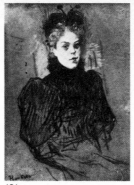
481

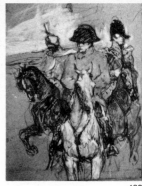
482

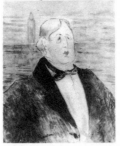
483

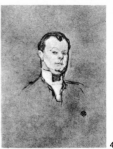
484

485

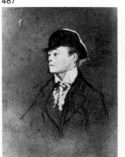
487

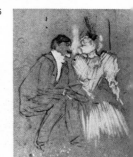
486

488

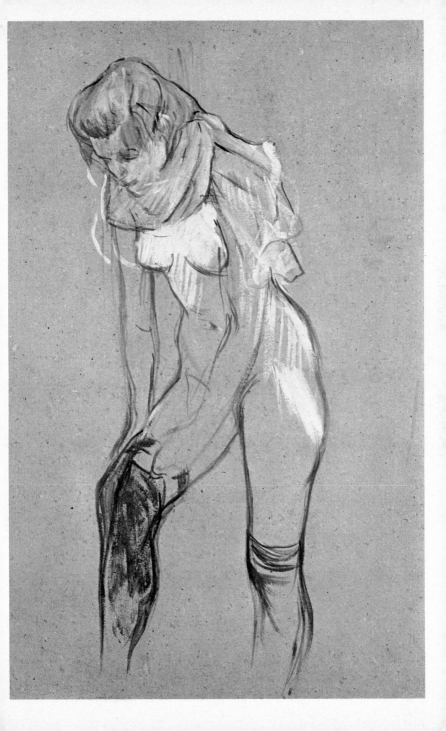

**489 The 'Clownesse' Cha-U-Kao, seated**
Cardboard/47 × 32/s. 1895
Paris, private collection

**490 Cha-U-Kao in her Dressing-room**
Cardboard/57 × 42/s.d. 1895
Paris, Musée du Louvre (Jeu de Paume)

**491 Cha-U-Kao**
Cardboard/81.5 × 59.5/s. 1895
Cannes, Jay Gould Collection
Study for No. 492

**492 Cha-U-Kao at the Moulin Rouge**
Canvas/75 × 55/s.d. 1895
Winterthur, Reinhart Collection

**493 Profile of a Woman**
Cardboard/46 × 39/red seal/ 1895
Private collection

**494 Portrait of May Belfort**
Cardboard/40.5 × 33.5/s. 1895
Private collection

**495 May Belfort singing**
Cardboard/50 × 33/s.d. 1895
Private collection

**496 May Belfort on Stage**
Cardboard/74 × 42/s.d. 1895
Belgium, private collection

**497 May Belfort on Stage**
Cardboard/63 × 48.5/s. 1895
Cleveland, Museum of Art
(Leonard C. Hanna Jr. Gift)

**498 May Belfort**
Paper/83 × 62/1895
USA, private collection
Study for a poster

**499 La Goulue**
Cardboard/67.5 × 46.5/s. 1895
Private collection

*Decorations for La Goulue's Booth at the Foire du Trône (Nos 500–1)*

**500 The Moorish Dance**
Canvas/300 × 300/s. 1895
Paris, Musée du Louvre

**501 Dance at the Moulin Rouge**
Canvas/300 × 300/s. 1895
Paris, Musée du Louvre

*

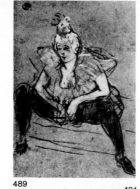
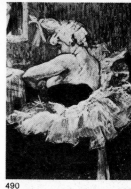

489

491    490

492

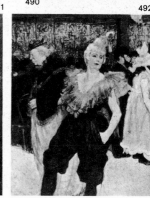

493    494

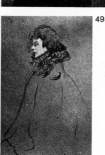

495    496    497

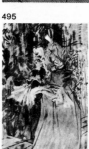
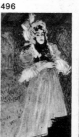
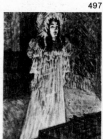

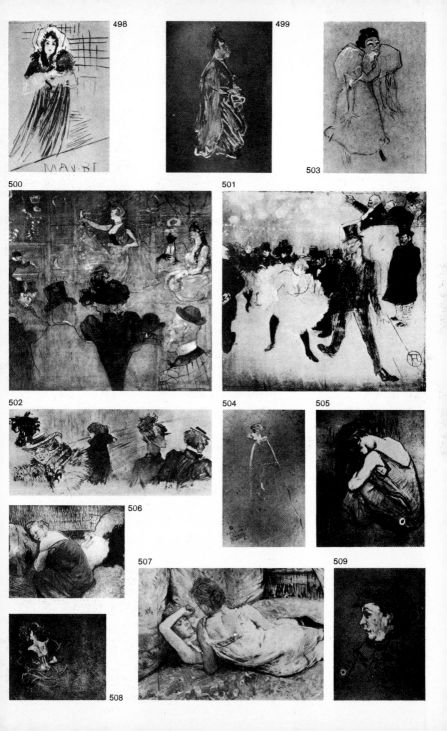

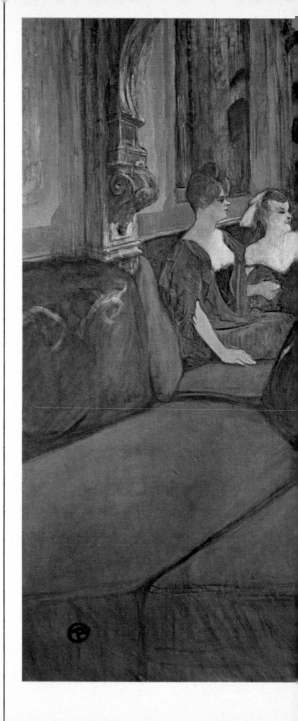

*502 Four Portraits of Women*
Canvas/30 × 75/s. 1895
Belgium, private collection

*503 Mlle Polaire*
Cardboard/56 × 41/s. 1895
Albi, Musée Toulouse-Lautrec

*504 'Manon, voici le soleil'*
Cardboard/60 × 38/s. 1895
Avignon, Musée Calvet
Study for the lithograph
*Etoiles filantes*

*505 Woman resting*
Wood/55 × 47/s. 1895
Private collection
Study for No. 506

*506 Two Women resting*
Cardboard/60 × 81/s.d. 1895
Dresden, Gemäldegalerie

*507 The Friends (Abandon)*
Cardboard/45 × 67/s. 1895
Zurich, private collection

*508 Portrait of Mme
Natanson*
Cardboard/62.5 × 74.5/
s.d. 1895
New York, Metropolitan
Museum of Art

*509 Head of a Woman
(Gabrielle)*
Cardboard/36 × 25/1895
Private collection

*In the Salon at the Rue des
Moulins (No. 470).*
*The women idly sit on sofas
waiting for clients in the
luxurious salon at the Rue des
Moulins, one of Paris's
smartest brothels.*

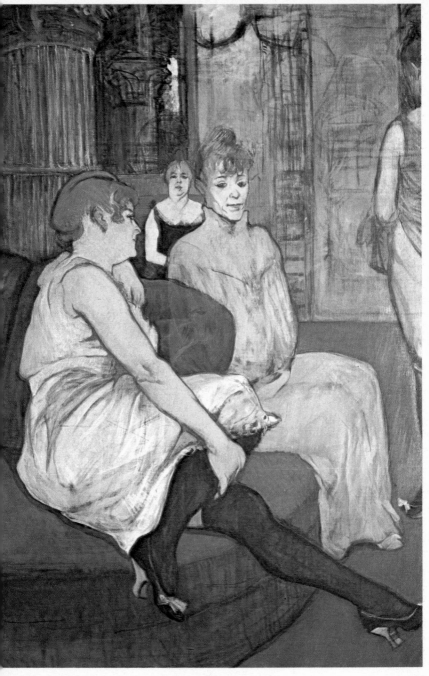

**510 The Divan**
Cardboard/63 × 80/s. 1895
New York, Metropolitan
Museum of Art

**511 Two Women in Bed**
Cardboard/64.5 × 84/s. 1895
Zurich, Bührle Collection

**512 'L'Argent'**
Paper/40 × 29.5/1895
Private collection
Study for the programme
cover for Fabre's comedy

**513 Pigeon-shooting**
Cardboard/23.2 × 29.8/
c. 1895
Private collection

**514 Stage-hands at the Opéra**
Canvas/42 × 32.3/1896
Albi, Musée Toulouse-
Lautrec
On the back: *Couple*, a pencil
sketch

**515 Nude Woman Seen from Behind**
Cardboard/74.3 × 53.2/1896
Albi, Musée Toulouse-
Lautrec
On the back: *Profile of a Woman*

**516 Profile of a Woman (Mlle Lucie Bellanger)**
Cardboard/57 × 45/s. 1896
Paris, Musée du Louvre

510

511

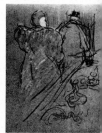
512

514
513

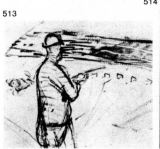

515

516

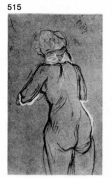

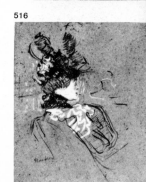

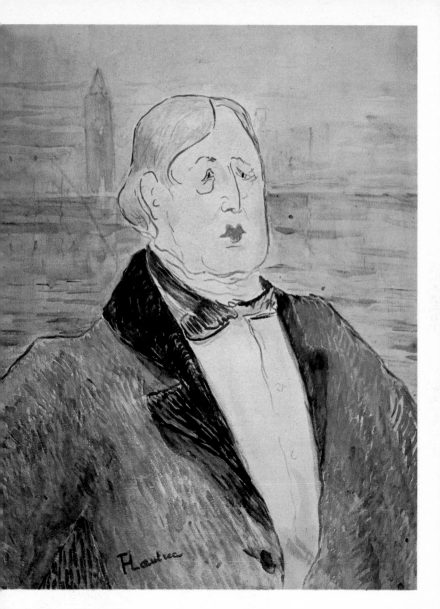

**Portrait of Oscar Wilde (No. 483).**
*Oscar Wilde made a great impression on Lautrec although, apart from their wit, the two men had little in common. Wilde was a giant of a man, but a notorious homosexual, while Lautrec, though physically stunted, was unequivocally heterosexual.*

*517 'La Toilette'*
Cardboard/36 × 27/s. 1896
Private collection

*518 'La Toilette'*
Cardboard/64 × 52/s. 1896
Paris, Musée du Louvre

*519 Model resting*
Cardboard/63 × 47.5/s. 1896
Belgium, private collection

*520 Ballerina*
Canvas/200 × 72/1896
Paris, private collection

*521 Portrait of Mme E. Tapié de Céleyran*
Wood/24 × 16.5/s. 1896
USA, private collection

*522 Nude Woman kneeling*
Cardboard/52 × 40/s. 1896
Private collection

*523 At the Concert*
Cardboard/80 × 60/s.d. 1896
Berne, private collection
Study for a poster

*524 'La Toilette': Woman washing*
Cardboard/60 × 40/s. 1896
Private collection
Study for a lithograph

*525 Woman putting on her Corset (A Passing Fancy)*
Canvas/103 × 65/s. 1896
Toulouse, Musée des Augustins
Study for a lithograph

517

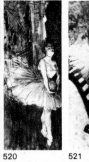

518

519

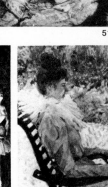

520 521

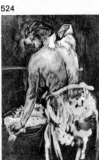

522

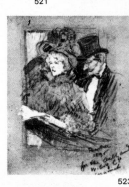

523

524

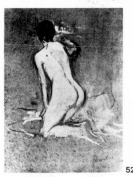

525

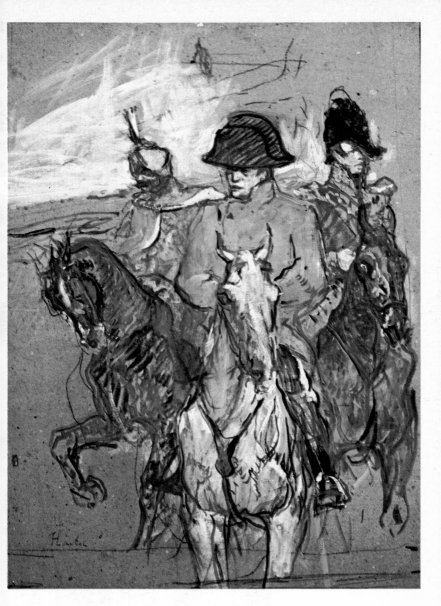

***Napoleon (No. 482).***
*Study for a competition organized to find a poster to advertise Sloane's* HISTORY OF NAPOLEON. *Lautrec came only third and the first prize went to Lucien Métivet.*

**526 Woman putting on her Corset**
Cardboard/84.2 × 60.3/s. 1896
Albi, Musée Toulouse-Lautrec
See previous entry

**527 Mlle Liane de Lancy at the Palais de Glace (Skating: Professional Beauty)**
Cardboard/61.8 × 48.9/red seal/1896
Albi, Musée Toulouse-Lautrec

**528 Chorus-girl at the Folies-Bergère**
Cardboard/71.7 × 51.5/red seal/1896
Albi, Musée Toulouse-Lautrec

**529 Lucie Bellanger**
Cardboard/80.7 × 60/s. 1896
Albi, Musée Toulouse-Lautrec

**530 Woman combing her Hair**
Cardboard/55.5 × 41/s. 1896
Albi, Musée Toulouse-Lautrec
Study for a lithograph

**531 Nude Woman combing her Hair**
Cardboard/56 × 40.5/red seal/1896
Private collection

**532 Woman taking off her Chemise**
Cardboard/70 × 45/s. 1896
France, private collection

**533 Cipa Godebski**
Cardboard/52 × 40/s. 1896
Athens and Paris, Stavros Niarchos Collection

526

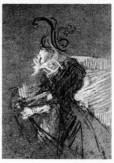
527

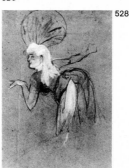
528

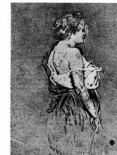
52

530

531

532

533

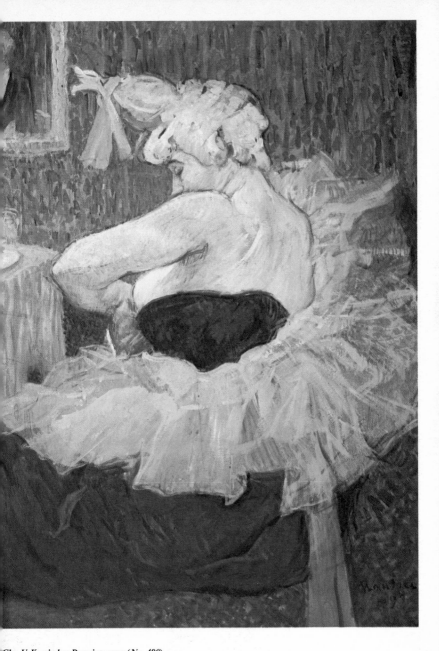

**Cha-U-Kao in her Dressing-room** (*No. 490*).

*Cha-U-Kao (a mock oriental spelling of her nickname* Chahut-Chaos – *'hurly-burly' – after a then popular dance) was a quadrille dancer, clown and acrobat at the Nouveau Cirque and the Moulin Rouge.*

**534 Marcelle Lender**
Cardboard/79 × 51.5/
s.d. 1896
USA, private collection

**535 Marcelle Lender dancing
the Bolero in Chilpéric**
Canvas/145 × 150/red seal/
1896
New York, John Hay
Whitney Collection

**536 Maxime Dethomas at the
Bal de l'Opéra**
Cardboard/68 × 52.5/
s.d. 1896
Washington, National
Gallery, Chester Dale
Collection

**537 Old Lady and her Maid**
Canvas/40 × 30/s./1896
New York, Salomon R.
Guggenheim Museum

**538 Mlle Eglantine's Troupe**
Cardboard/73 × 90.6/1896
USA, private collection

**539 'Elles' (The Hand-mirror)**
Cardboard/60 × 36.5/s. 1896
Private collection
Study for a lithograph

**540 Woman at her Mirror**
Paper/31.1 × 25.4/1896
New York, Salomon R.
Guggenheim Museum

**541 Woman's Head**
Cardboard/42 × 36/red seal/
1896
Private collection

534

535

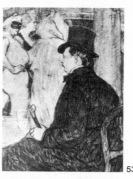

536

53

538

540

53

541

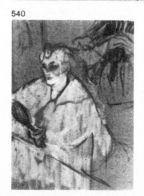

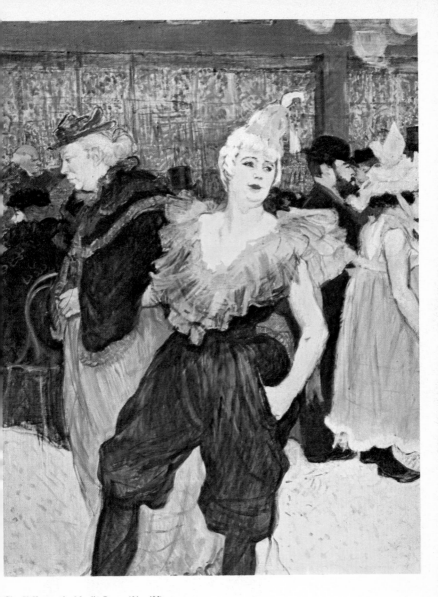

**Cha-U-Kao at the Moulin Rouge** (*No. 492*).
*The 'clownesse'* Cha-U-Kao *enters the Moulin Rouge on the arm of Gabrielle, the dancer. At the back, on the right, Tristan Bernard is seen in profile.*

**542 Lassitude**
Cardboard/31 × 40/s. 1896
Cannes, Florence F. Jay
Gould Collection

**543 Circassian Horseman**
Paper/23.5 × 31.5/red seal/
1896
Private collection

**544 Nude before a Mirror**
Cardboard/63 × 48/s.d. 1897
New York, private collection

**545 Henri Nocq**
Cardboard/83 × 45/s. 1897
Private collection
Study for No. 546

**546 Henri Nocq**
Cardboard/64 × 49/s.d. 1897
New York, private collection

**547 Béatrice Tapié de
Céleyran**
Wood/42 × 27/s. 1897
Buenos Aires, Santa Marina
Collection

**548 Misia Natanson**
Cardboard/56 × 46/s. 1897
Private collection

**549 Misia Natanson playing
the Piano**
Cardboard on wood/80 × 95/
s.d. 1897
New York, Salomon R.
Guggenheim Museum

**La Goulue's Booth at the
Foire du Trône (No. 500;
detail, The Moorish Dance).**
*When La Goulue set up on her
own at the Foire du Trône she
asked Lautrec, who had made
her famous with the Moulin
Rouge poster, to decorate her
booth. Watching her Moorish
dance are Sescau, Gabriel
Tapié de Céleyran and
Maurice Guibert. (Standing
close by, but not shown in this
detail, are Jane Avril, seen
from behind, Lautrec and
Felix Fénéon.)*

68

542

544

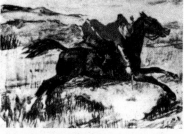
543

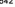

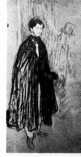
546

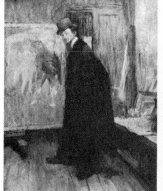
548

549

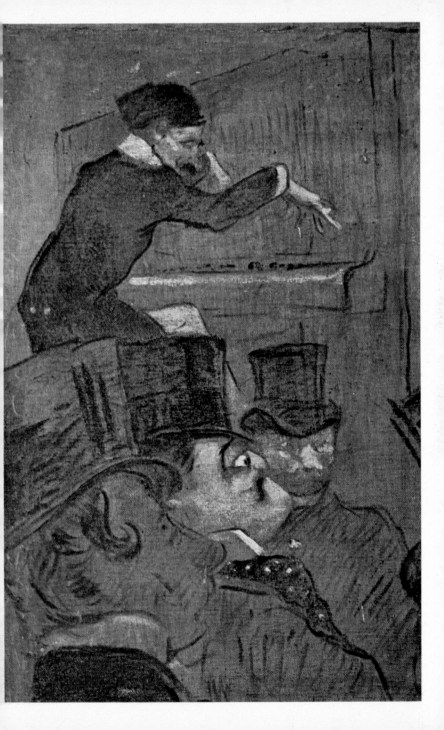

**550 Woman sitting up in Bed**
Cardboard/55 × 46/s. 1897
Private collection

**551 M. de Lauradour**
Cardboard/64.6 × 81/s. 1897
New York, private collection

**552 The Poet Paul Leclercq**
Cardboard/54 × 64/1897
Paris, Musée du Louvre

**553 Bouboule, Mme Palmyre's Bulldog**
Cardboard/61 × 43.5/red seal/1897
Albi, Musée Toulouse-Lautrec
Study for a lithograph

**554 Berthe Bady, the Actress**
Cardboard/70.3 × 60/1897
Albi, Musée Toulouse-Lautrec

**555 Nude lying on a Divan**
Wood/32.5 × 42/s. 1897
Merion (USA), Barnes Foundation

**556 Crouching Nude with Red Hair**
Cardboard/47 × 60/s.d. 1897
Private collection

**557 Redhead seated on a Divan**
Cardboard/58.5 × 48/s. 1897
Winterthur, private collection

**558 'La Grande Loge'**
Cardboard/53.8 × 46.2/s. 1897
Private collection
Study for a lithograph

**559 Seated Woman**
Cardboard/63 × 48/s. 1897
Munich, Neue Pinakothek

**560 Snobbery ('Chez Larue')**
Cardboard/68 × 52.5/s. 1897
Private collection

**561 'L'Image' (Marthe Mellot standing, in profile)**
Cardboard/33 × 24/s. 1897
Private collection

**562 Misia Natanson**
Cardboard/68.6 × 53.2/1897
USA, private collection

**563 'Alors vous êtes sage?'**
Cardboard/55.8 × 41.3/s. 1897
Private collection

550

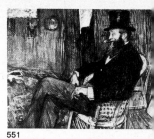
551

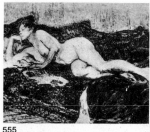
552

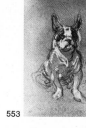
553

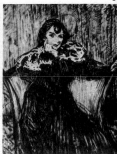
55

555

556

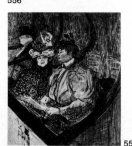
558

55

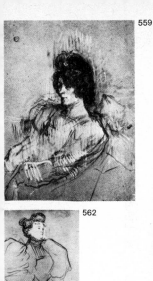

559

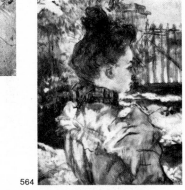

560

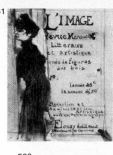

561

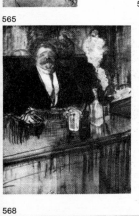

562

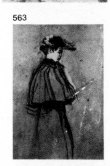

563

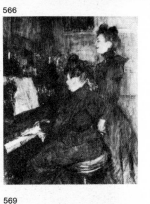

564

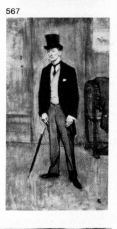

565

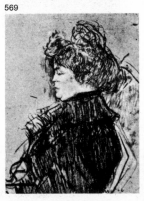

566

567

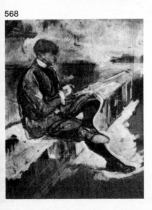

568

569

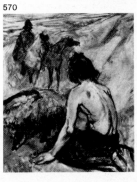

570

*564 Béatrice Tapié de Céleyran*
Wood/27 × 22/s. 1897
Private collection

*565 At the Café: the Fat Customer and the Anaemic Cashier*
Cardboard/81.5 × 60/1898
Zurich, Kunsthaus

*566 The Singing Lesson: Mlle Dihau and Mme Jeanne Favereau*
Wood/82 × 78/s.d. 1898
Cairo, Museum of Modern Art

*567 Portrait of Louis Bouglé*
Wood/65 × 35/red seal/1898
Private collection

*568 Louis Bouglé at Arromanches*
Wood/63 × 51/red seal/1898
Paris, Musée du Louvre

*569 Andrée Ciriac, 'Commère' at the Ambassadeurs and the Eldorado*
Cardboard/65 × 49/s. 1898
Private collection

*570 The Falconer*
Canvas/87 × 75/red seal/1898
Private collection

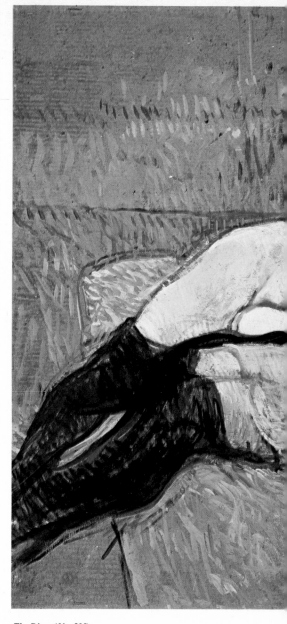

**The Divan (No. 510).**
*One of Lautrec's many paintings of private moments in the lives of prostitutes.*

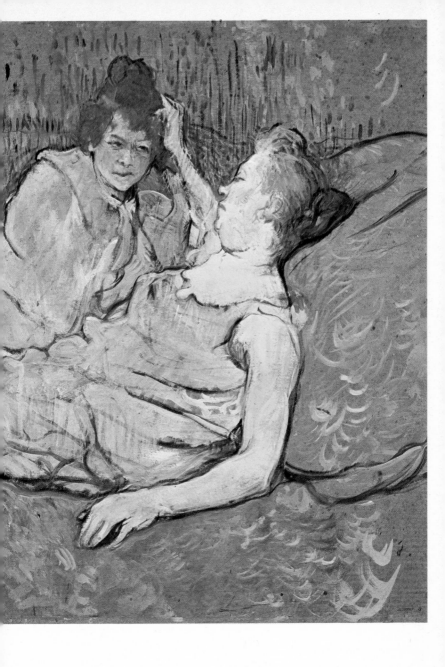

**571 Two Horsemen in Armour**
Canvas/81 × 65/red seal/1898
Private collection

**572 Head of an English Lady**
Wood/35 × 27/red seal/1898
Geneva, private collection

**573 The Sphinx (Prostitute)**
Cardboard/86 × 65/s.d. 1898
Zurich, private collection

**574 English Soldier smoking a Pipe**
Cardboard/61.8 × 47.6/s. 1898
Albi, Musée Toulouse-Lautrec

**575 Standing Nude**
Cardboard/80 × 53/s. 1898
Albi, Musée Toulouse-Lautrec

**576 'A la toilette': Madame Poupoule**
Wood/60.8 × 49.6/1898
Albi, Musée Toulouse-Lautrec

**577 The Bed**
Wood/41 × 32/s.d. 1898
London, Chester Beatty Collection

**578 The Barmaid in London**
Cardboard/63 × 47.5/s. 1898
Private collection

571

572

573

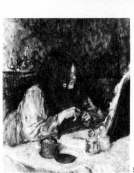
574

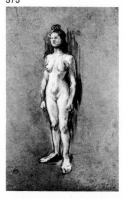
575

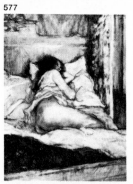
576

577
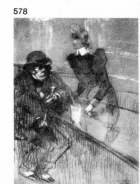

578

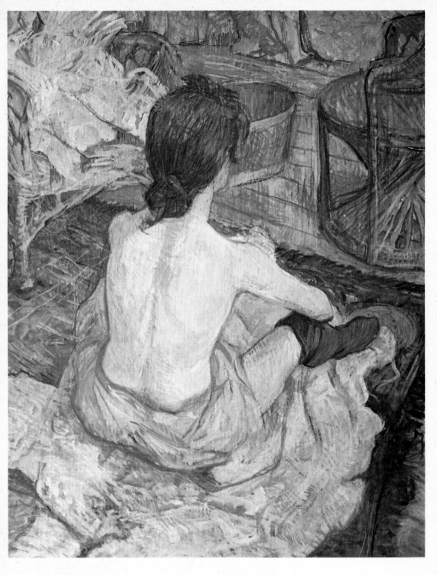

**'La Toilette'** (*No. 518*).
*During this period many of Lautrec's pictures are finished in every detail, whereas in most of his work everything except the main subject is merely suggested.*

**Marcelle Lender dancing the Bolero in** Chilpéric (*No. 535*). *Lautrec shows Marcelle Lender, an actress at the Théâtre des Variétés, dancing the bolero in* CHILPÉRIC, *an operetta which would have been forgotten long ago were it not for this picture.*

**579 Mme Natanson**
Cardboard/26 × 18/1898
Private collection

**580 'Job' Cigarette Paper**
Paper/97 × 69.5/s. 1898
Private collection

**581 Jacqueline Lescluse**
Canvas/24 × 16.5/s. 1898
USA, private collection

**582 Emilie**
Wood/41.2 × 32.5/s. c. 1898
Private collection

**583 In Bed**
Cardboard/53.5 × 44/c. 1898
Switzerland, private
collection

**584 Prostitute**
Cardboard/56 × 41/c. 1898
Private collection

**585 In a Private Room at the Rat Mort (Lucy Jourdan)**
Canvas/55 × 46/s. 1899
London, Courtauld Institute
of Art

**586 'Le Coucher' (Mme Poupoule)**
Wood/61 × 50/s. 1899
Private collection

579

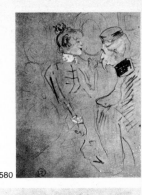
580

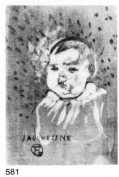
581

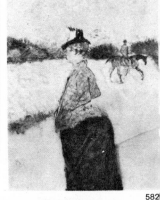
582

583
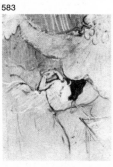

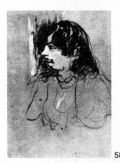
584

585
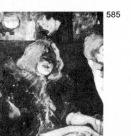

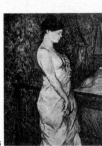
586

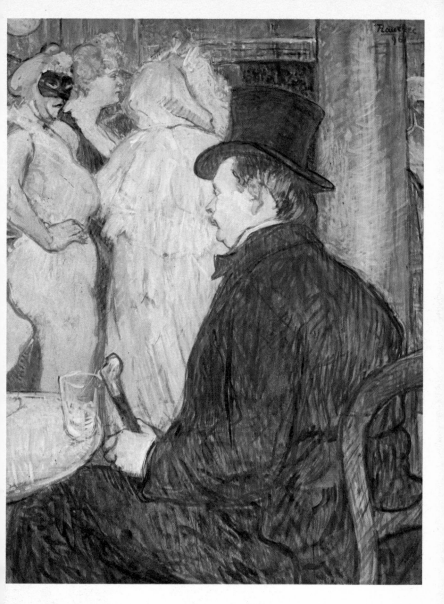

**Maxime Dethomas at the Bal de l'Opéra** (*No. 536*).
*Maxime Dethomas, painter and engraver, was a friend of Lautrec and Vuillard and Zuloaga's brother-in-law.*

**587 Dolly the Singer at the Star in Le Havre**
Wood/27 × 21.5/1899
Cannes, Florence F. Jay Gould Collection

**588 Mlle Nys**
Wood/27 × 21.7/s.d. 1899
Private collection

**589 The English Girl from the Star in Le Havre**
Wood/41 × 32.8/s.d. 1899
Albi, Musée Toulouse-Lautrec

**590 Horsewoman**
Cardboard/55 × 41/s. 1899
Private collection

**591 At the Races**
Canvas/46 × 55/s. 1899
Albi, Musée Toulouse-Lautrec

**592 The Old General**
Cardboard/25 × 20/1899
Private collection

**593 My Keeper**
Wood/43 × 36/s.d. 1899
Albi, Musée Toulouse-Lautrec

**594 Romain Coolus**
Cardboard/56.2 × 36.8/s. 1899
Albi, Musée Toulouse-Lautrec

**Standing Nude (No. 575).**
*Lautrec excelled at restrained, economical paintings such as this, where the background is left bare cardboard, drawing the eye to the essentials – the woman's body and facial expression.*

587

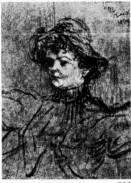

588

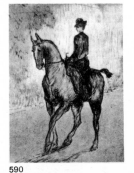

590

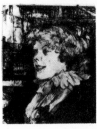

589

592

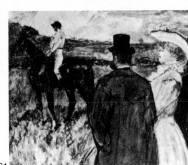

591

593

594

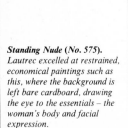
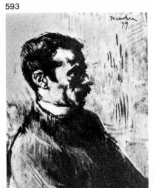
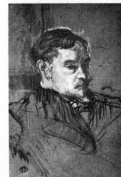

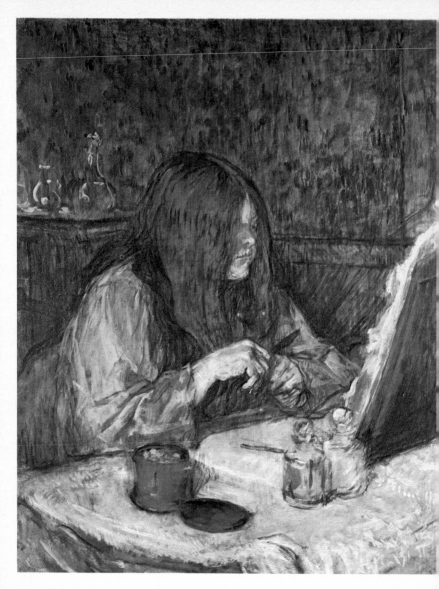

'*A la toilette*': *Madame Poupoule* (*No. 576*).
*Mme Poupoule was a prostitute Lautrec knew at this time. The several pictures he did of her display his best qualities as a painter.*

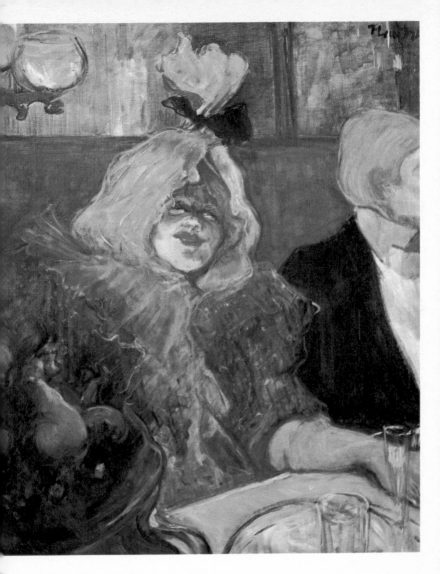

**In a Private Room at the Rat Mort** (*Lucy Jourdan*) (*No. 585*).
*After leaving the nursing home to which his family had sent him for treatment Lautrec had only two years to live. During this time he painted fifty pictures, some of them filled with surprising life and vigour, like the smile of the woman, Lucy Jourdan, portrayed here, in a private room at the restaurant, the Rat Mort.*

**595 At Armenonville: a Private Room**
Cardboard/67 × 52/s. 1899
Private collection

**596 Cow's Skull in profile**
Wood/22 × 27/1899
Albi, Musée Toulouse-Lautrec

**597 Cow's Skull from the Front**
Wood/39.9 × 24.5/1899
Albi, Musée Toulouse-Lautrec

**598 Clown from the Cirque Fernando**
Cardboard/19 × 15/s. 1899
Private collection

**599 Two Yoked Oxen**
Cardboard/34 × 60/red seal/1899
Private collection
Study for Jules Renard's *Histoires Naturelles*

**600 Girl with a Hoop**
Cardboard/44 × 56/s. 1899
Private collection
Study for a fan

**601 Dolly the Singer at the Star in Le Havre**
Paper/54 × 42.5/1899
São Paulo, Museu de Arte

**602 Horsewoman and Collie**
Cardboard/55 × 46/red seal/c. 1899
France, private collection

**603 A Rest during the Masked Ball**
Cardboard/56 × 39/red seal/c. 1899
Private collection

*The English Girl from the Star in Le Havre (No. 589).*
*This painting was commissioned by Maurice Joyant when Lautrec was desperately in need of money. The portrait of the girl, with her enchanting, warm smile, now hangs in the museum in Albi.*

595

59

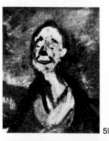
596

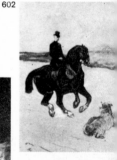
601

602

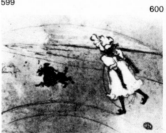
598

6

599

600

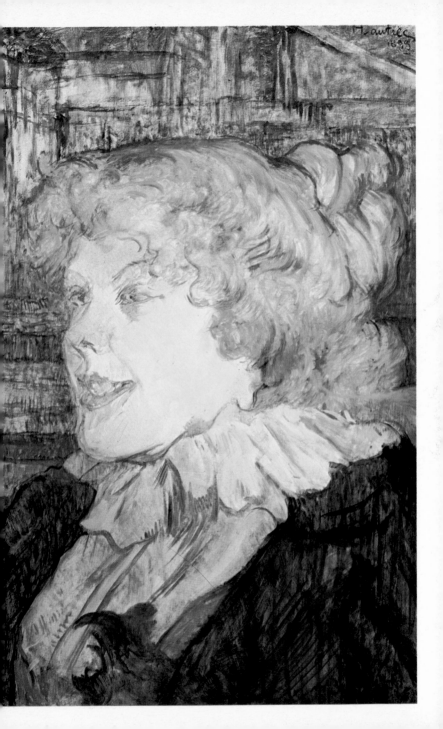

**604 Woman's Head**
Cardboard/45.3 × 31.5/
c. 1899
USA, private collection

**605 In Bed**
Cardboard/24.5 × 35.6/s.
c. 1899
Private collection

**606 Interior**
Wood/24 × 17/c. 1899
Amsterdam, van Gogh
Collection

**607 Portrait of M. de Villechenon**
Canvas/81 × 62/1900
Munich, Neue Pinakothek

**608 Mme Marthe: Bordeaux**
Canvas/90 × 80/red seal/1900
Kurashiki-shi (Japan), Ohara
Museum

**609 Boy with a Dog (Mme Marthe's Son and the Bitch Pamela)**
Canvas/130.5 × 70/1900
Private collection

**610 Maurice Joyant**
Cardboard/95 × 66.5/s. 1900
Paris, Musée du Louvre
Study for No. 611

**611 Maurice Joyant in the Baie de Somme**
Wood/116.5 × 81/red seal/
1900
Albi, Musée Toulouse-
Lautrec

*Isidore de Lara's* Messaline
(Nos. 612–17)

*Romain Coolus (No. 594).*
*Romain Coolus (real name*
*René Weill) was a playwright*
*born in Rennes in 1868.*
*Lautrec stayed in brothels with*
*him and illustrated several of*
*his works.*

86

604

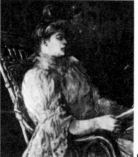
605

607

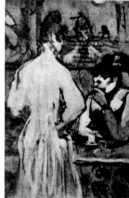
606

608

60

610

611

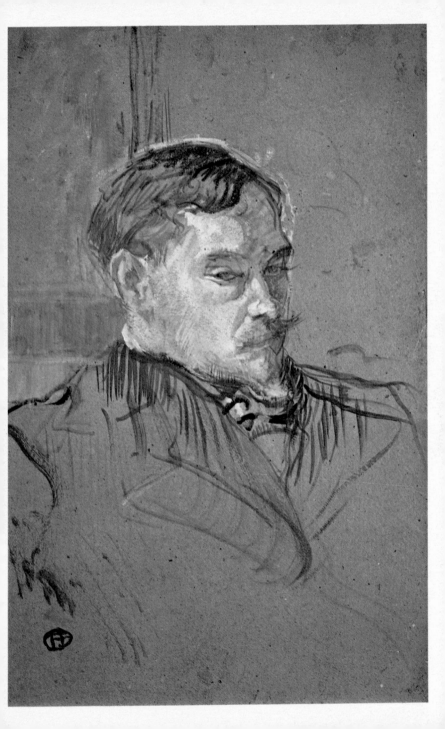

**612 Messaline**
Canvas/92 × 68/red seal/1900
Zurich, Bührle Collection

**613 Messaline coming down
the Staircase**
Canvas/100 × 73/red seal/
1900
Los Angeles (USA), County
Museum (Gard De Silva gift)

**614 Messaline on her Throne**
Canvas/96 × 77.5/red seal/
1900
Private collection

**615 Messaline seated on her
Throne gives her Hands to be
Kissed by her Lover**
Canvas/55 × 46/red seal/1900
Albi, Musée Toulouse-
Lautrec

**616 Messaline on her Throne**
Canvas/46 × 61/red seal/1900
Albi, Musée Toulouse-
Lautrec

**617 Messaline: Two Nudes on
a Divan**
Canvas/55 × 46/red seal/1900
Albi, Musée Toulouse-
Lautrec

\*

**618 Paul Viaud at Taussat**
Cardboard/79 × 40/s. 1900
Buenos Aires, Santa Marina
Collection

**619 'A la toilette'**
Wood/49 × 50/s.d. 1900
Private collection

**Maurice Joyant in the Baie de
Somme (No. 611).**
*Maurice Joyant was the same
age as Lautrec. They were at
school together and became
lifelong close friends. As
director of the Goupil gallery,
where he succeeded Vincent
Van Gogh's brother, Théo, he
organized the first exhibitions
of Lautrec's work, during his
lifetime and after his death
and set up the Musée
Toulouse-Lautrec in Albi.*

612

613

614
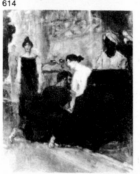

615
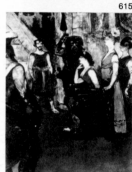

616
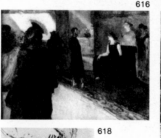

617
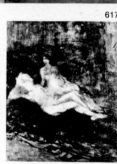

618

619

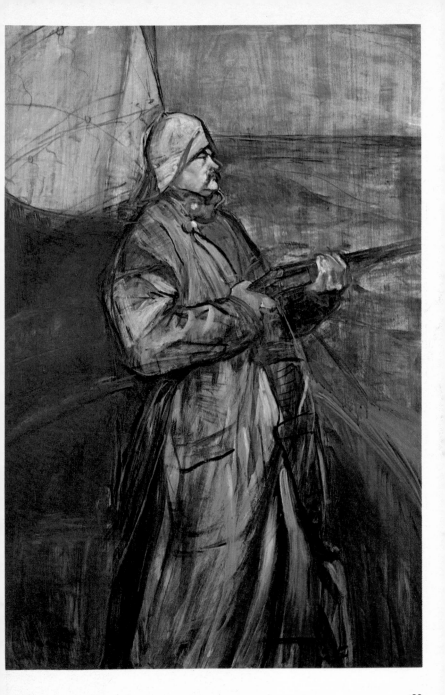

**620 The Violinist Dancla**
Canvas/92 × 67.5/red seal/
1900
Private collection

**621 Trap harnessed to a Cob**
Canvas/61 × 50/red seal/1900
Albi, Musée Toulouse-
Lautrec

**622 'L'Assommoir'**
Wood/55 × 43/s. 1900
Private collection
Study for a theatre
programme

**623 The Modiste (Mlle
Margouin)**
Cardboard/35 × 30/1900
Private collection

**624 The Modiste (Mlle
Margouin standing)**
Cardboard/76 × 52/s. 1900
Private collection
Study for No. 625

**625 The Modiste (Mlle
Margouin)**
Wood/61 × 49.3/s. 1900
Albi, Musée Toulouse-
Lautrec

**626 'La Gitane'**
Cardboard/78 × 52/1900
Private collection
There is another study for
this poster in the Musée
Toulouse-Lautrec, Albi

**627 Riders in the Bois de
Boulogne**
Canvas/81.3 × 64.5/red seal/
1901
Private collection

**628 In the Bois de Boulogne**
Cardboard/55 × 46/s.d. 1901
Private collection
There is a study for the
woman's figure in the Musée
Toulouse-Lautrec, Albi

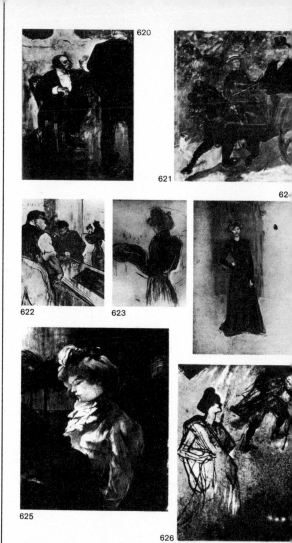

620

621

622

623

625

626

627

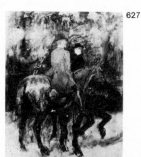

628

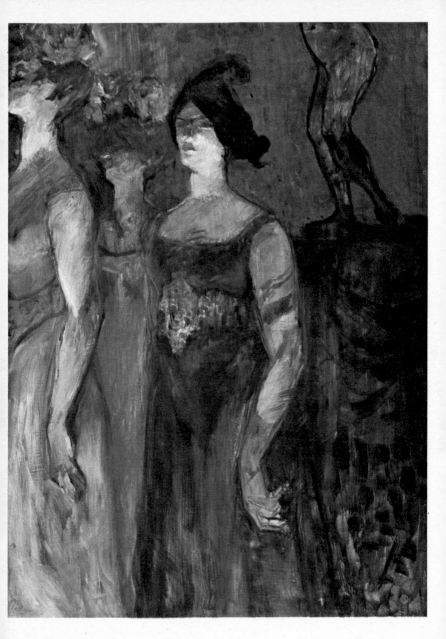

*Messaline (No. 612).*
This picture shows the new direction Lautrec's work took in his last year of life. Where possible he increasingly stripped his work of inessentials, concentrating on the life and movement of his figures.

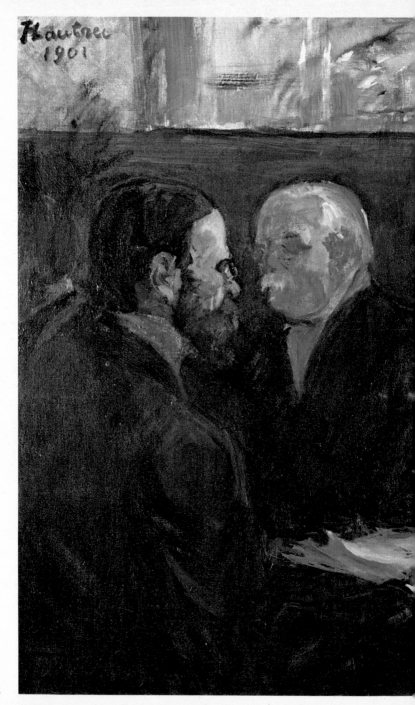

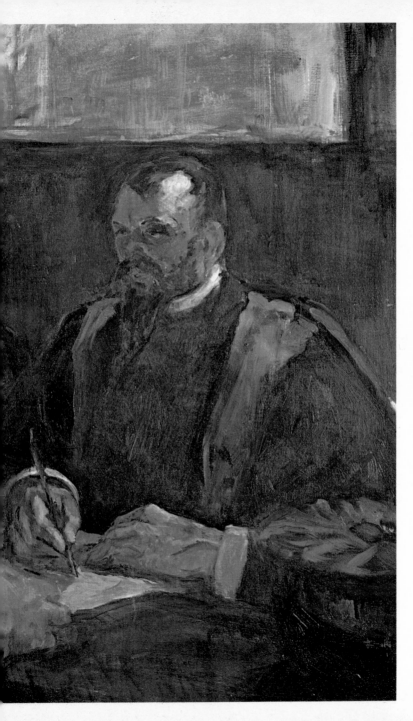

**629 Paul Viaud dressed as an Admiral**
Canvas/139 × 153/1901
São Paulo, Museu de Arte

**630 Woman lifting up her Chemise**
Wood/56 × 43/s.d. 1901
Private collection

**631 On the Look-out: M. Fabre, an Officer in the Reserves**
Cardboard/61 × 50/s.d. 1901
Buenos Aires, Santa Marina Collection

**632 Portrait of André Rivoire**
Canvas/57.5 × 46/s. 1901
Paris, Musée du Palais des Beaux-Arts

**633 Doctor Robert Würtz**
Cardboard/71.5 × 52.8/1901
Albi, Musée Toulouse-Lautrec
Study for No. 634

**634 An Examination at the Faculty of Medicine in Paris**
Canvas/65 × 81/s.d. 1901
Albi, Musée Toulouse-Lautrec

**635 Portrait of Octave Raquin**
Canvas/56 × 46/s.d. 1901
São Paulo, Museu de Arte

**636 Monseigneur Lecot, Archbishop of Bordeaux**
Wood/24 × 16/1901
Private collection

**637 Portrait of Manzi**
Wood/86 × 59.5/c. 1901
New York, Whitney Museum of American Art

**638 The Errand-boy**
Paper/33 × 25/?
Private collection
Not reproduced

*An Examination at the Faculty of Medicine in Paris (No. 634).* (pp. 92–93)
*Gabriel Tapié de Céleyran, Lautrec's first cousin, defends his doctoral thesis in medicine before Professors Würtz and Fournier.*

629

630

631

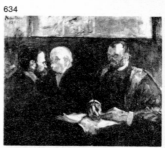
632    633

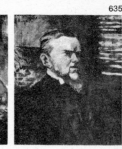
634    635

636

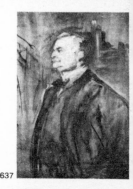
637

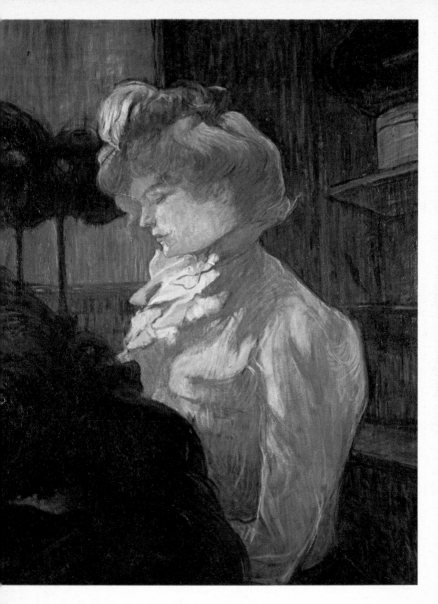

**The Modiste (Mademoiselle Margouin) (No. 625).**
*Mlle Margouin was a friend of Adolphe Albert, Joyant and Lautrec who painted several pictures of her. Her gentle face, with its halo of light from an unexplained source, recalls the portrait of the artist's mother painted twenty years before.*

# Selected Bibliography

The basic text for the study of Toulouse-Lautrec is the detailed and comprehensive catalogue in 6 volumes of all the artist's works, compiled by M. G. DORTU (*Toulouse-Lautrec and his Oeuvre*. New York 1971)

## General Works and Monographs

BAZIN G., BERNARD T., COOLUS R., HUYGHE R., VUILLARD E.: Special edition of *L'amour de l'Art*, April 1931.

BERNARD T.: 'Toulouse-Lautrec, sportsman', *La Revue Blanche*, 15 May 1895.

CASSON J.: 'Toulouse-Lautrec', *L'Art et les Artistes*, April 1938.

COOPER D.: *Henri de Toulouse-Lautrec*, New York 1952, Paris 1955.

COQUIOT G.: *Toulouse-Lautrec*, Paris 1913 and 1920.

DE CÉLEYRAN M. TAPIÉ: *Notre oncle Lautrec*, Geneva 1953.

DORTU M. G., GRILLAERT M., ALDHEMAR J.: *Toulouse-Lautrec en Belgique*, Paris 1955.

DURET TH.: *Lautrec*, Paris, 1920.

FLORISOONE, M., DORTU M. G., JULIEN E.: *Toulouse-Lautrec*, Paris 1951.

FOCILLON H.: 'Lautrec', *Gazette des Beaux-Arts*, June 1931.

GEFFROY G.: 'Lautrec', *La Vie Artistique*, VI–VII, 1900.

HEIMEL A. W.: *Henri de Toulouse-Lautrec*, Munich 1904.

HUISMAN P., DORTU M. G.: *Lautrec par Lautrec*, Paris 1964.

HUYGHE R.: 'Aspects de Toulouse-Lautrec', *La Revue du Tarne*, 1938.

JEDLICKA G.: *Henri de Toulouse-Lautrec*, Berlin 1929 and Zurich 1943.

JOYANT M.: *Henri de Toulouse-Lautrec*, Paris 1926–7.

JOYANT-MANZI: Special edition of the *Figaro illustré*, April 1902.

JOURDAIN F.: *Souvenirs*, Paris 1951.

JULIEN E.: *Pour comprendre Lautrec*, Albi 1953.

KELLER H.: *Toulouse-Lautrec*, Paris 1970.

LE CLERCQ P.: *Autour de Toulouse-Lautrec*, Paris 1921.

MACK G.: *Toulouse-Lautrec*, New York 1938.

MARX R.: 'Toulouse-Lautrec', *La Revue universelle*, 13 Dec 1901.

NATANSON TH.: 'Toulouse-Lautrec', *L'Art vivant*, May 1938, *Un Henri de Toulouse-Lautrec*, Geneva 1952.

RIVOIRE A.: 'Toulouse-Lautrec', *La Revue de l'Art*, April 1902.

ROGER-MARX C.: *Toulouse-Lautrec*, Paris 1957.

## Graphic Studies

ADHEMAR J.: *Toulouse-Lautrec: Lithographies-Pointes seches. Oeuvre complet*, Paris 1965.

JOURDAIN F.: 'L'affice moderne et Toulouse-Lautrec', *La Plume*, Nov 1883.

JULIEN E.: *Dessins de Toulouse-Lautrec*, Munich 1942, *Les Affiches de Toulouse-Lautrec*, Monte Carlo 1950.

ROGER-MARX C., APPOLONIO U: *Toulouse-Lautrec: Lautrec*, Paris 1948.

ROGER-MARX C.: APPOLONIO U., *Toulouse-Lautrec: L'oeuvre graphique*, 1952.

ROTZLER W.: *Les affiches de Toulouse-Lautrec*, Basle 1942.

## Catalogues

ADHEMAR J.: (ed Cain J., Valery-Radot J.) Catalogue of the retrospective exhibition of graphics at the Bibliothèque Nationale in Paris, Paris 1951.

Catalogue of the retrospective exhibition at the Manzi-Joyant Gallery, Paris 1914.

Catalogue of the retrospective exhibition at the Musée des Arts decoratifs, Paris 1931.

CHARLES-BELLET L.: *Le Musée d'Albi*, Albi 1951.

FLORISOONE M.: Catalogue of the commemorative exhibition at the Paris Orangery, Paris 1951.

GENIAUX, C.: Catalogue of the Musée Toulouse-Lautrec at Albi, Albi 1922.

JULIEN E.: Catalogue of the Musée Toulouse-Lautrec at Albi, Albi 1952.

**Photocredits**

Musée Toulouse-Lautrec, Albi: p. 43. All other colour and black and white pictures are from the Rizzoli Photoarchive.

**Photocredits**

First published in Great Britain by Granada Publishing 1981 Frogmore, St Albans, Herts AL2 2NF

First published in the United States of America 1981 by Rizzoli International Publications, Inc. 712 Fifth Avenue, New York, New York 10019 Copyright © Rizzoli Editore 1979 This translation copyright © Granada Publishing 1980 ISBN 0-8478-0364-3 LC 80-54043 Printed in Italy